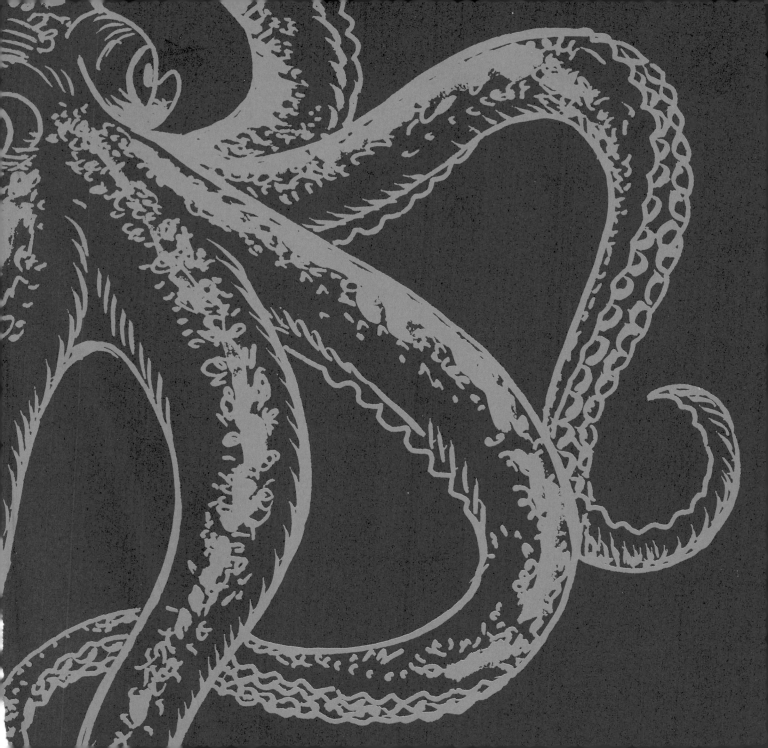

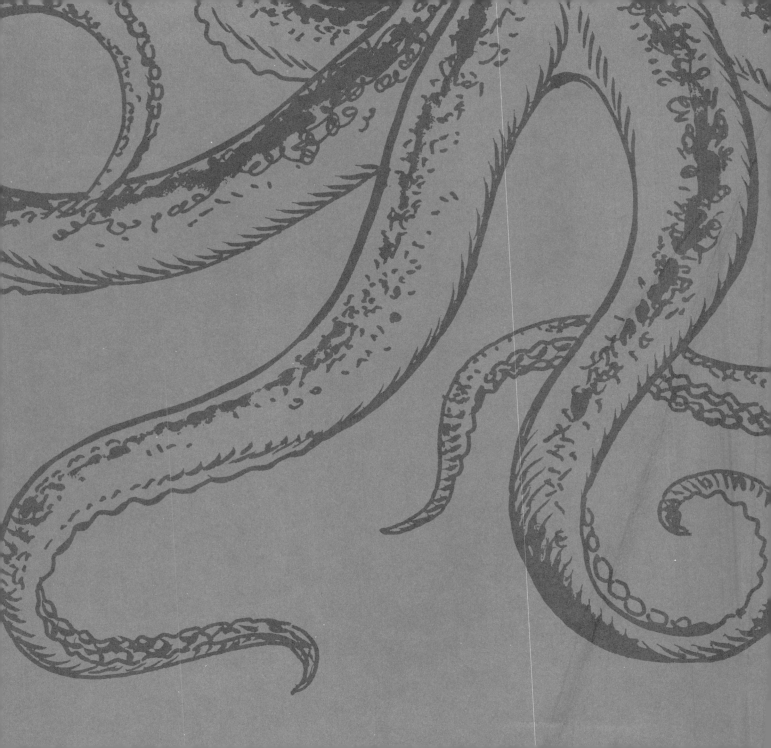

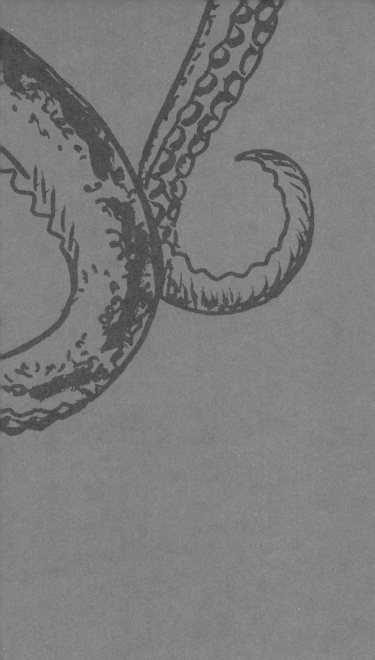

ANIMALS

Handmade Illustration

850 Vintage Drawings
850 Illustrations Vintage
850 Ilustraciones Vintage
850 Illustrazioni Vintage

First published in English, French, Spanish,
and Italian by Promopress Editions, 2016

Copyright © 2017 Promopress Editions
Promopress is a brand of:
Promotora de prensa internacional S.A.
C/ Ausiàs March 124 - 08013 Barcelona (Spain)
T + 34 93 245 14 64 - F + 34 93 265 48 93
info@promopress.es
www.promopresseditions.com
Facebook: Promopress Editions
Twitter: Promopress Editions @PromopressEd

Author: Joan Escandell
Concept & Design: Alehop
www.alewebs.com

English Translation: Tom Corkett
French Translation: Marie Pierre Teuler/ Marjorie Gouzée
Italian Translation: Luigia Rovito
Spanish Proofreading: Promopress Editions

ISBN: 978-84-16504-19-0
Printed in China

Visit our website to download all the illustrations contained in this book.
Promotional code:
ZB9WQAACMN
All the illustrations are protected by copyright and intended solely for private use.
The numbers correspond to those of the pages. The content is downloadable page
by page. All the illustrations have been designed by the author.

www.promopresseditions.com/Descargas/Material Extra Gratuito
www.promopresseditions.com>Downloads >Extra Free Material

ANIMALS

Handmade Illustration

850

VINTAGE
DRAWINGS
ILLUSTRATIONS
VINTAGE
ILUSTRACIONES
VINTAGE
ILLUSTRAZIONI
VINTAGE

By **JOAN
ESCANDELL**

promopress

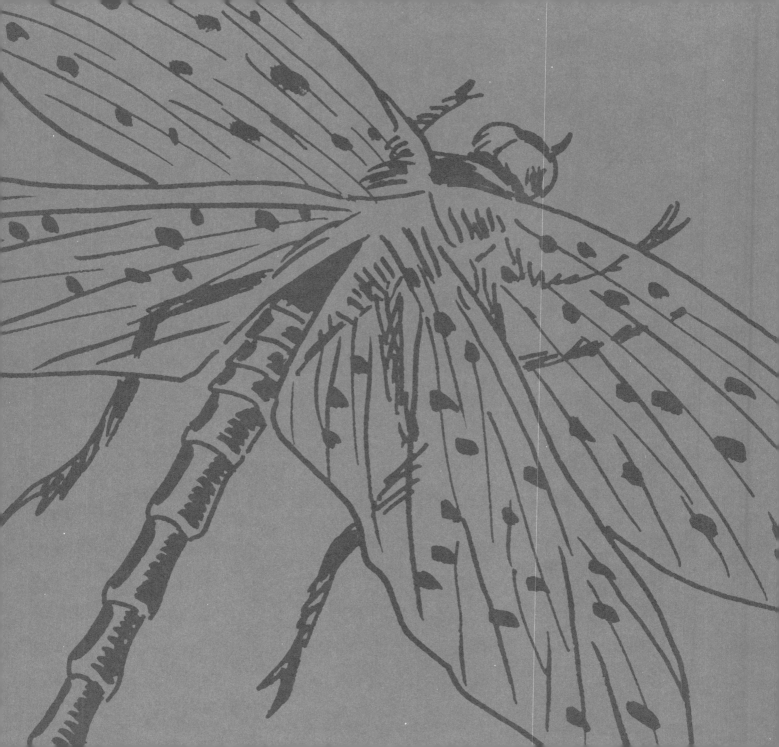

INDEX

INDEX
ÍNDICE
INDICE

8 **THE AUTHOR**
L'auteur
El autor
L'autore

11 **INSECTS**
Insectes
Insectos
Insetti

21 **AMPHIBIANS AND REPTILES**
Amphibiens et reptiles
Anfibios y reptiles
Anfibi e rettili

31 **AQUATIC CREATURES**
Animaux aquatiques
Animales acuáticos
Animali marini

65 **BIRDS**
Oiseaux
Aves
Uccelli

87 **PETS AND FARM ANIMALS**
Animaux de compagnie et domestiques
Animales domésticos y de granja
Animali domestici e di allevamento

103 **MAMMALS FROM FORESTS,
MEADOWS AND MOUNTAINS**
Mammifères de la forêt, de la prairie et des montagnes
Mamíferos de bosques, praderas y montes
Animali dei boschi, dei prati e delle montagne

123 **MAMMALS FROM THE SAVANNA,
THE DESERT AND THE RAINFORESTS**
Mammifères de la savane, du désert et des forêts tropicales
Mamíferos de la sabana, el desierto y la selva
Mammiferi della sabana, del deserto e delle foreste

THE AUTHOR

J. ESCANDELL

Joan Escandell (Ibiza, 1937) is one of Spain's most internationally well-known and influential illustrators. Born in Ibiza in 1937, his career began in the 1960s at the iconic publisher Editorial Bruguera, where he contributed drawings to legendary series such as *El Capitán Trueno* and *Joyas literarias*, as well as creations of his own such as *Sargento Furia* (which was written by Cassarel) and *Astromán* (which was written by Victor Mora, creator of *El Capitán Trueno*).

In the late 1970s he stepped into the European market, with his career highlights from this period including his own creation *Antares*, which he drew for French audiences for fourteen years. He has worked in Italy, the USA, England and Japan, where he produced illustrations for a wide range of genres and aesthetic styles. He created comic strips for series such as *Masters of the Universe* and for Disney his works include, among many other characters, *Mickey Mouse*, *Cinderella*, *The Lion King* and *Pocahontas*.

In recent years he has contributed to the world of German television, developing a magazine based around the famous children's series *Bibi & Tina*.

Following the success of *Handmade Illustrations*, Joan's first collection of illustrations produced with India ink and presenting a wide range of subjects, this new volume contains over 850 illustrations of many different species of animals, from insects and sea creatures to the largest and most unusual mammals. All the illustrations can be downloaded and freely used in graphic design and illustration projects. *ANIMALS, Handmade Illustration* is a collection that is timeless in its feel and impeccable in its quality.

Joan Escandell (Ibiza, 1937) est un des dessinateurs espagnols les plus connus au-delà de nos frontières. Il a commencé sa carrière dans les années 1960 comme poulain de la célèbre maison d'édition Bruguera qui l'avait choisi pour illustrer des séries mythiques comme *El capitán Trueno* ou *Joyas literarias*. Il illustrera ensuite ses propres albums comme *Sargento Furia* (à partir de scénarios de Cassarel) ou *Astromán* (à partir de scénarios de Victor Mora, le créateur du personnage *El Capitán Trueno*).

À la fin des années 1970, il se lance sur le marché européen avec des oeuvres originales comme la série *Antares*, qu'il illustrera pendant quatorze ans pour les lecteurs français. Depuis cette époque, il travaille pour les publics de différents pays dont l'Italie, les États-Unis, l'Angleterre, le Japon, etc., passant par tous les genres et registres esthétiques. Il réalise des séries médiatiques comme *Les Maîtres de l'univers*, et dessine pour Disney de nombreux personnages dont *Mickey*, *Cendrillon*, *Le Roi Lion* et *Pocahontas*.

Au cours des douze dernières années, il s'est davantage tourné vers le monde télévisuel allemand. Il a notamment conçu un magazine entièrement consacré à la célèbre série pour enfants *Bibi & Tina*.

Après le succès d'*Handmade Illustrations*, son premier recueil d'illustrations à l'encre de Chine et à la typologie très variée, ce nouveau volume propose plus de 850 dessins d'animaux de toutes les espèces, des insectes et créatures marines aux mammifères plus grands en passant par les bêtes les plus étranges. Elles peuvent toutes être téléchargées, ce qui permet une utilisation libre dans des créations graphiques et illustrations. *ANIMALS, Handmade Illustration* est un ouvrage intemporel d'une qualité irréprochable.

J. ESCANDELL

Joan Escandell (Ibiza, 1937) es uno de los dibujantes españoles con mayor proyección y recorrido fuera de nuestras fronteras. Se inicia en la década de 1960 bajo la tutela de la emblemática Editorial Bruguera, dibujando series míticas como *El capitán Trueno* o *Joyas literarias* y creaciones propias como *Sargento Furia* (con guión de Cassarel) o *Astromán* (con guión de Víctor Mora, creador de *El Capitán Trueno*). A finales de la década de 1970 se lanza al mercado europeo, destacando de esta época su obra *Antares* que dibuja durante catorce años para el público francés.

Joan ha trabajado en Italia, Estados Unidos, Inglaterra, Japón, etc., tocando todo tipo de géneros y registros estéticos. Realiza historietas de series mediáticas como *Masters of the Universe* y para Disney dibuja *Mickey*, *La Cenicienta*, *El rey León* y *Pocahontas*, entre otros muchos personajes.

En los últimos años ha colaborado en el universo televisivo alemán, desarrollando toda una revista dedicada a la famosa serie infantil *Bibi & Tina*.

Tras el éxito de *Handmade Illustrations*, su primera colección de ilustraciones realizadas con tinta china y de tipología muy variada, este nuevo volumen contiene más de 850 ilustraciones de animales de todas las especies, desde insectos y criaturas marinas hasta los mamíferos más grandes y los animales más curiosos, todos ellos descargables para ser utilizados libremente en creaciones de diseño gráfico e ilustración. *ANIMALS, Handmade Illustration* es una colección de aire intemporal y de una impecable calidad.

Joan Escandell (Ibiza, 1937) è uno tra i disegnatori spagnoli che gode di maggiore visibilità e notorietà al di fuori dei confini iberici. La sua carriera inizia negli anni '60 per l'emblematica casa editrice Editorial Bruguera, per la quale disegna serie entrate nel mito come *El capitán Trueno*, o *Joyas literarias*, insieme a creazioni proprie come *Sargento Furia* (con testi di Cassarel) o *Astromán* (con testi di Víctor Mora, ideatore di *El Capitán Trueno*).

Alla fine degli anni '70 avviene il lancio sul mercato europeo, con opere come la sua *Antares*, che disegnerà lungo un periodo di quattordici anni per il pubblico francese.

Joan ha lavorato in Italia, Stati Uniti, Inghilterra, Giappone, ecc., esplorando tutti i generi e registri estetici. Ha realizzato strisce per serie mediatiche come *Masters of the Universe*, e per Disney ha disegnato *Topolino*, *Cenerentola*, *Il Re Leone* e *Pocahontas*, tra gli altri numerosi personaggi.

Negli ultimi anni ha collaborato con il mondo televisivo tedesco, sviluppando una rivista dedicata alla famosa serie per bambini *Bibi & Tina*.

Dopo il successo di *Handmade Illustrations*, la sua prima collezione di illustrazioni di tipologia diversa realizzate a china, questo nuovo volume contiene più di 850 illustrazioni di animali di tutte le specie, dagli insetti e le creature degli abissi, fino ai mammiferi più grandi e agli animali più curiosi, ognuno di essi scaricabile per essere utilizzato liberamente nell'ambito di creazioni di design grafico e illustrazione. *ANIMALS, Handmade Illustration* è una collezione senza tempo, e un lavoro di qualità impeccabile.

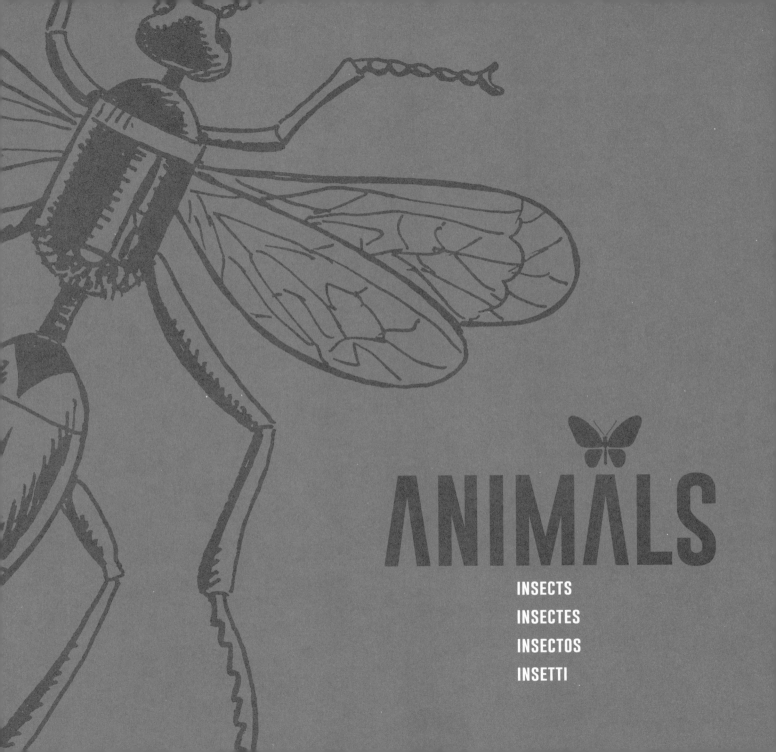

ANIMALS

INSECTS

INSECTES

INSECTOS

INSETTI

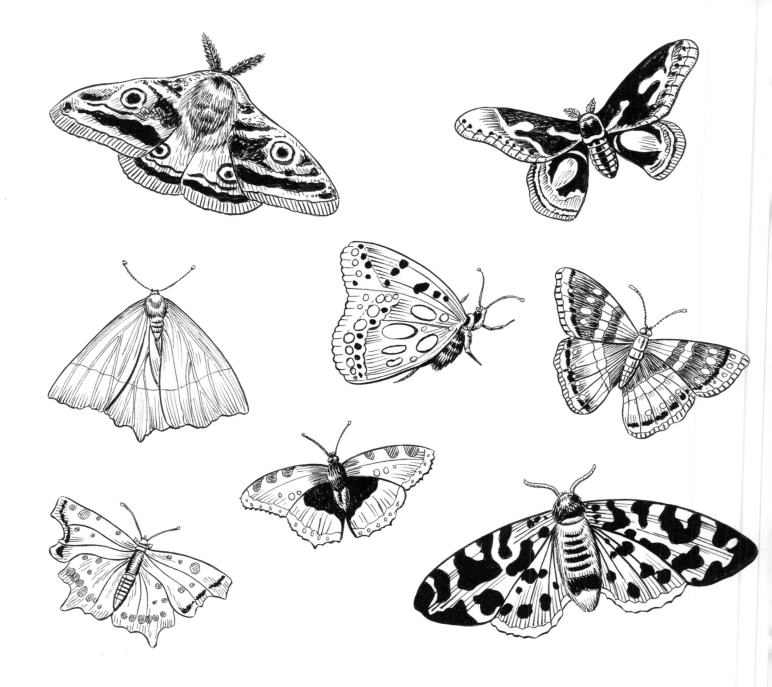

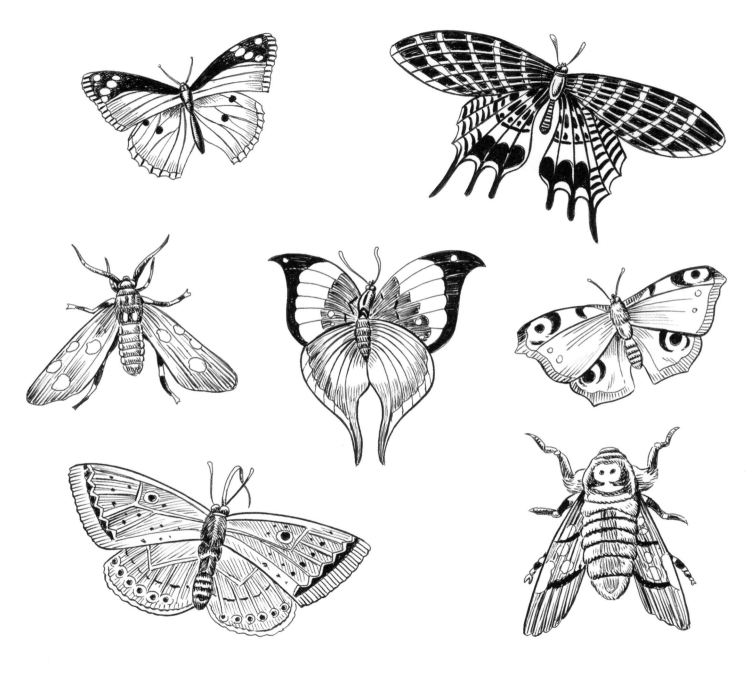

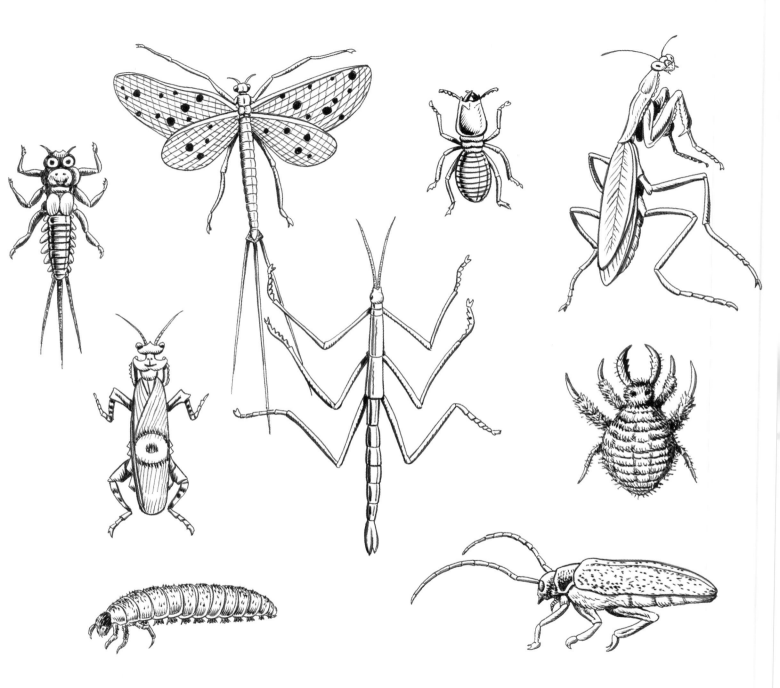

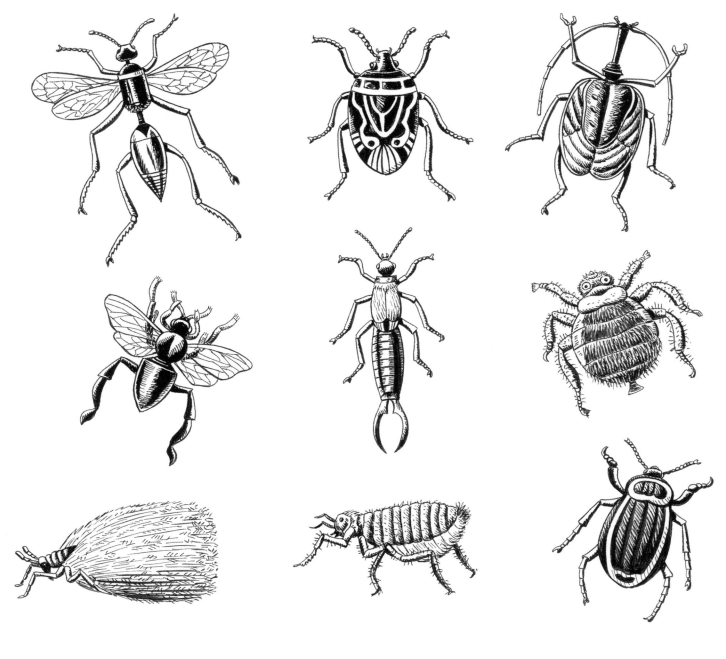

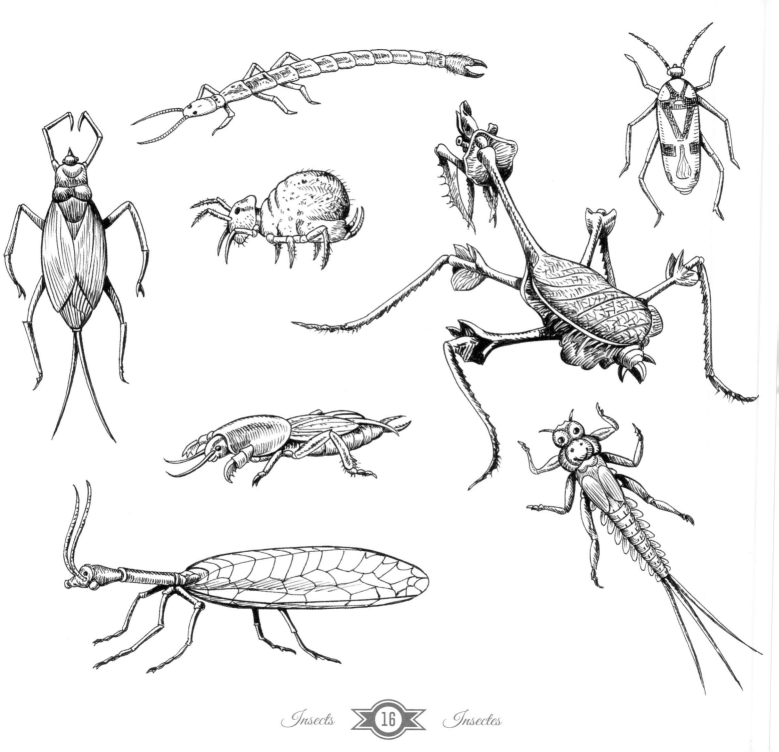

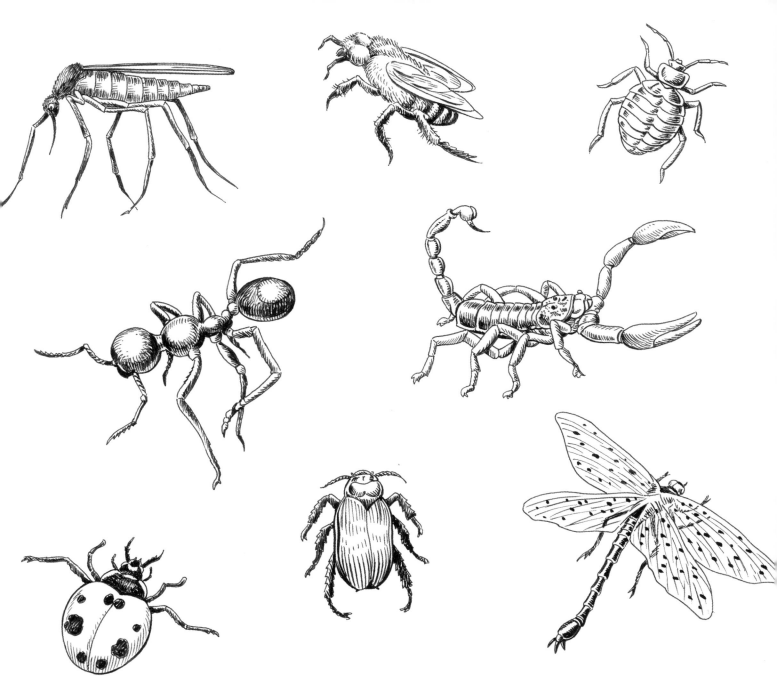

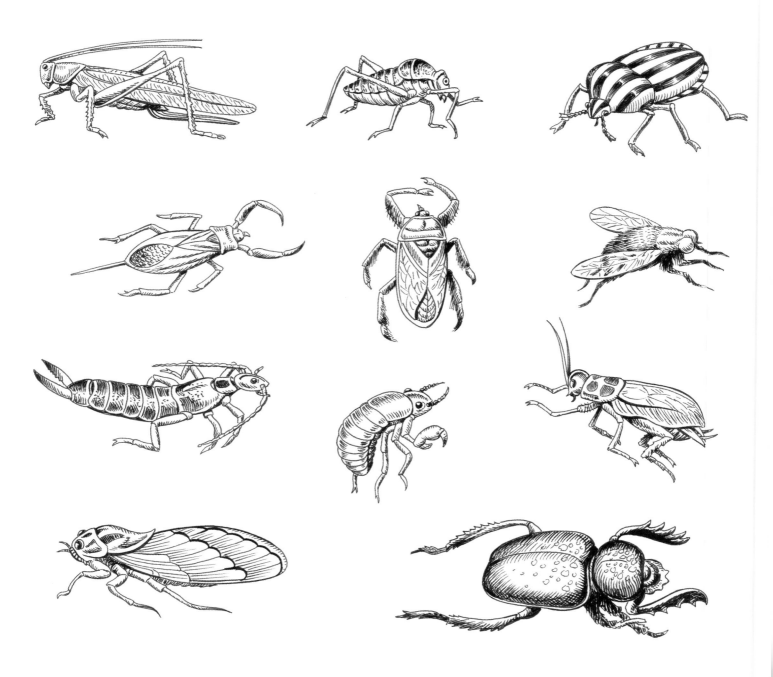

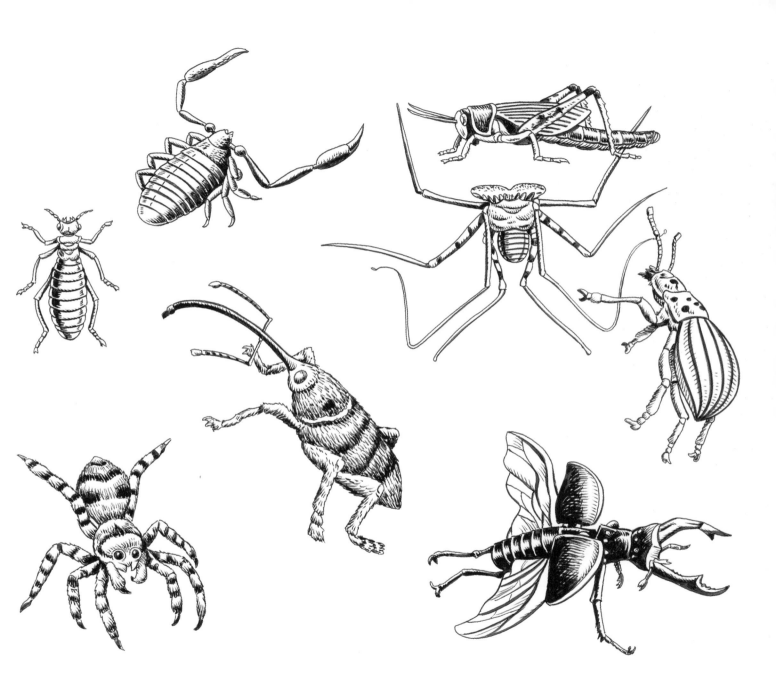

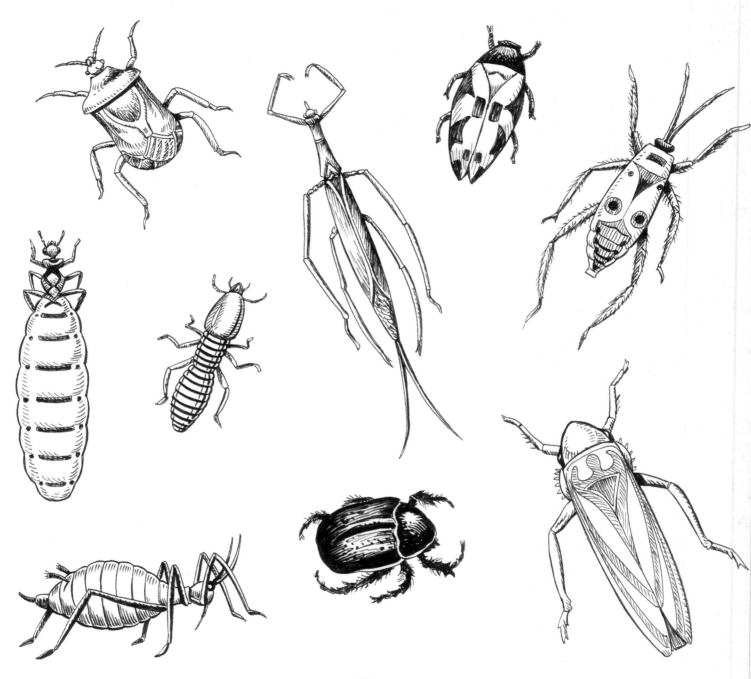

ANIMALS

AMPHIBIANS AND REPTILES

AMPHIBIES ET REPTILES

ANFIBIOS Y REPTILES

ANFIBI E RETTILI

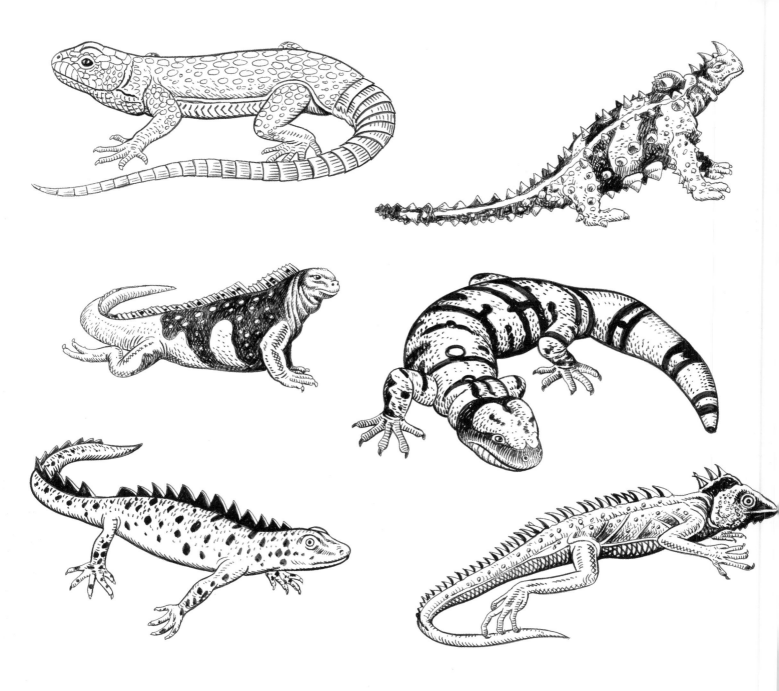

 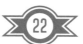

 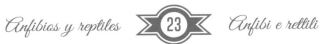

 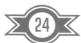

 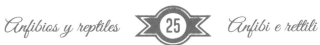

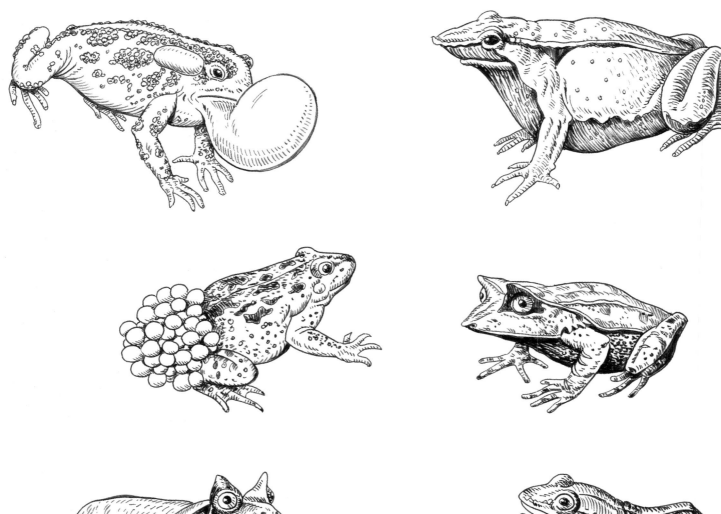

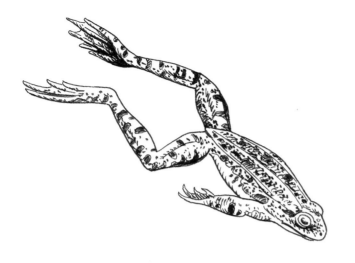

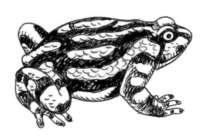

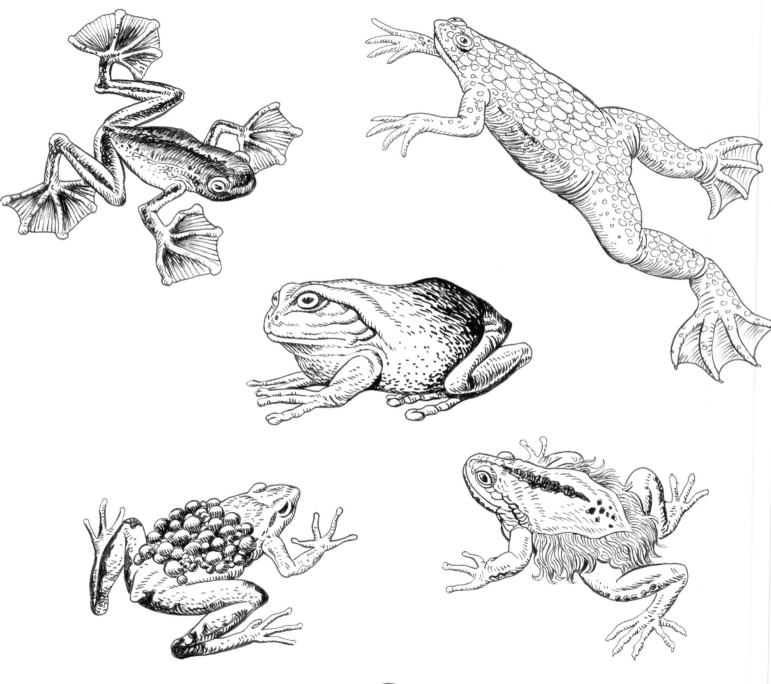

 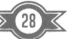

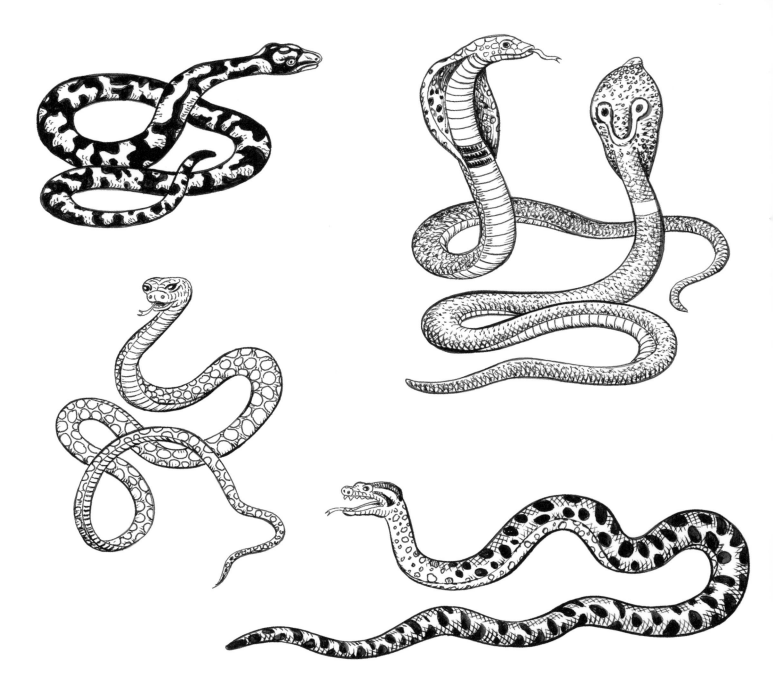

 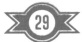

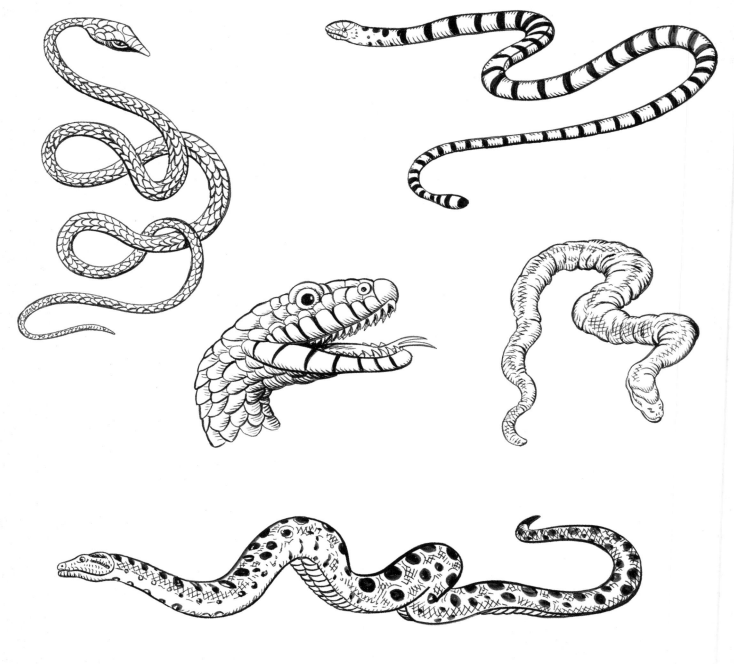

ANIMALS

AQUATIC CREATURES
ANIMAUX AQUATIQUES
ANIMALES ACUÁTICOS
ANIMALI ACQUATICI

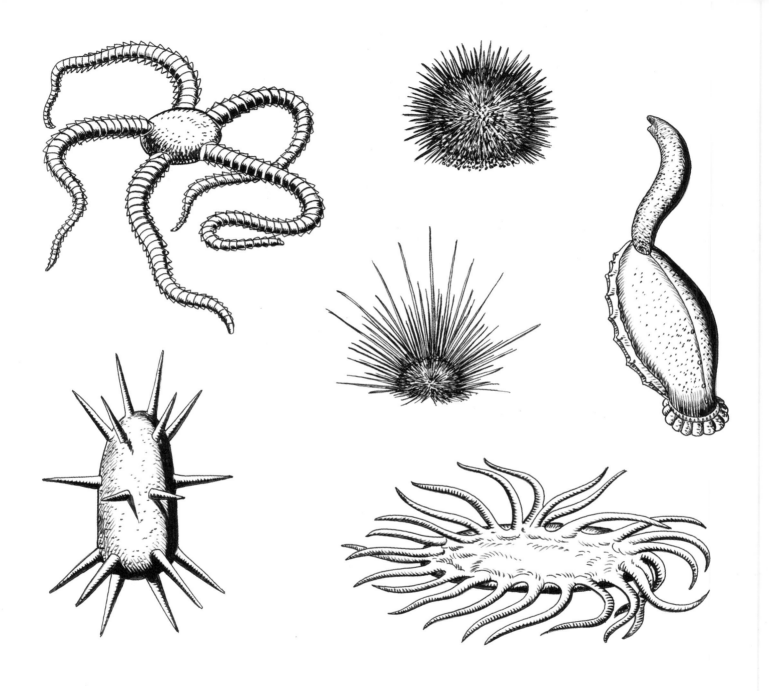

 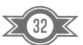

 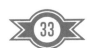

 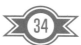

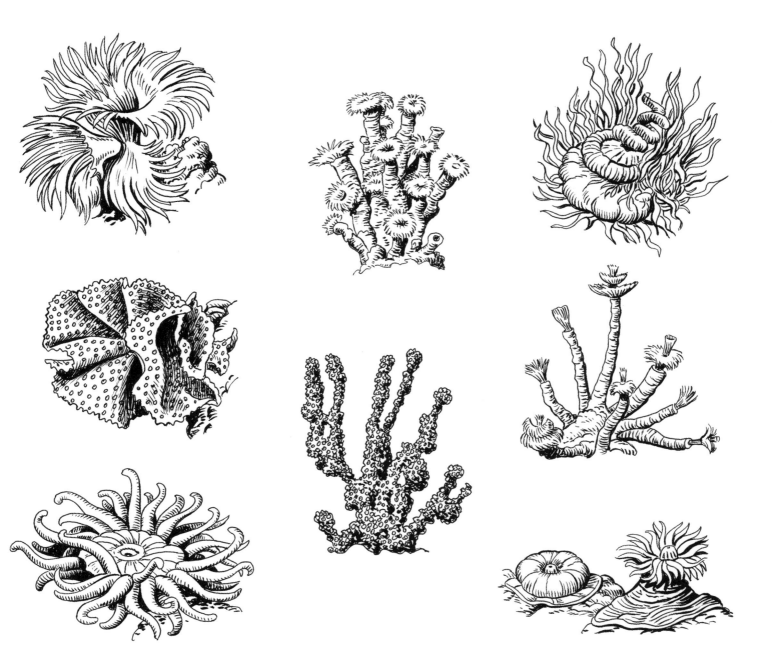

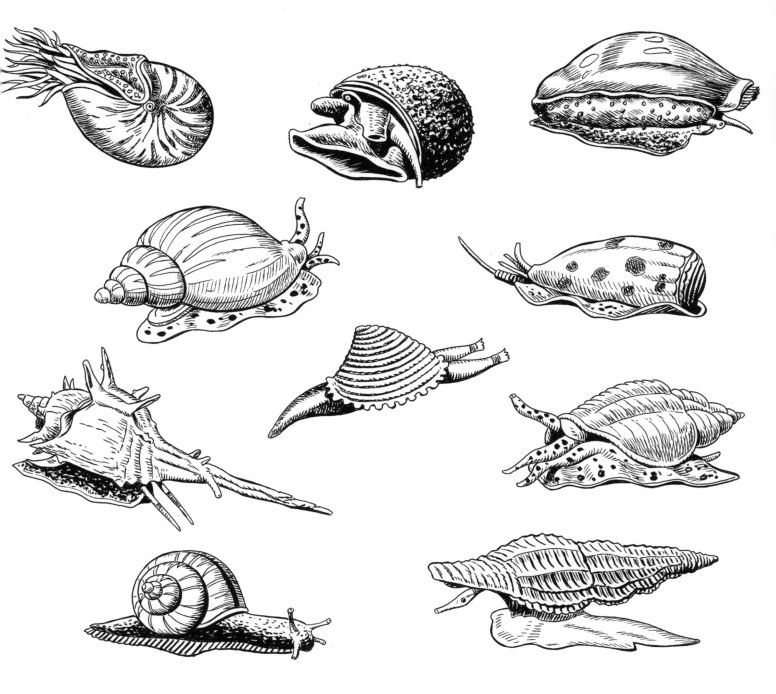

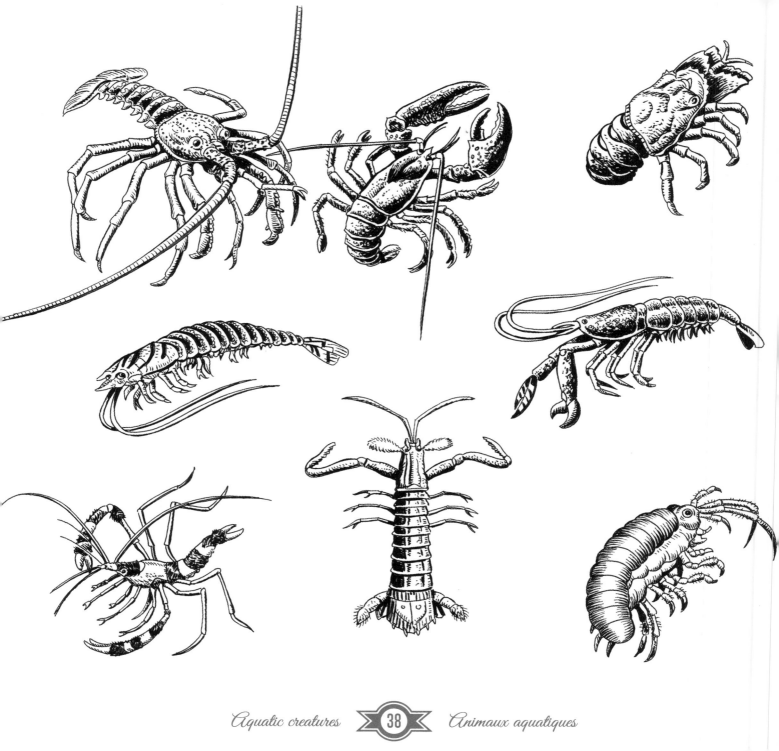

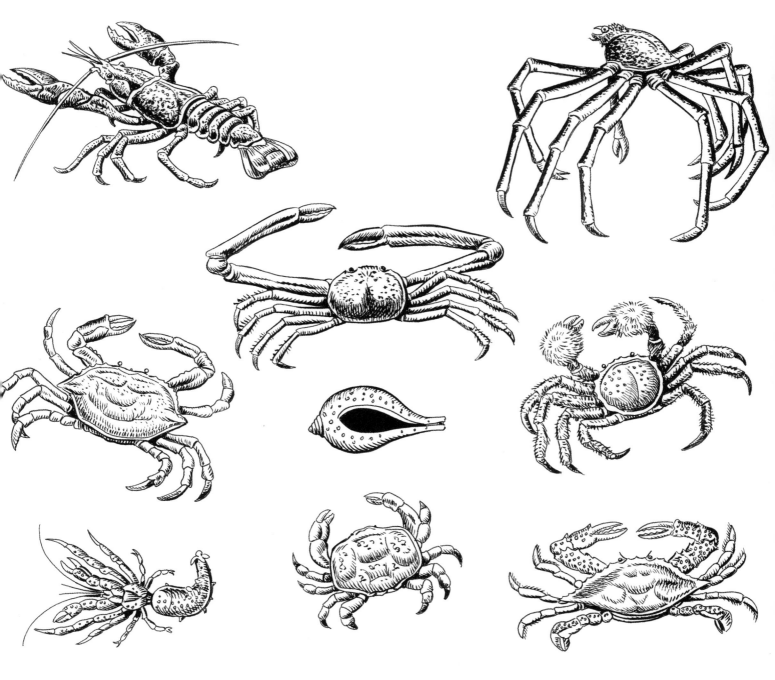

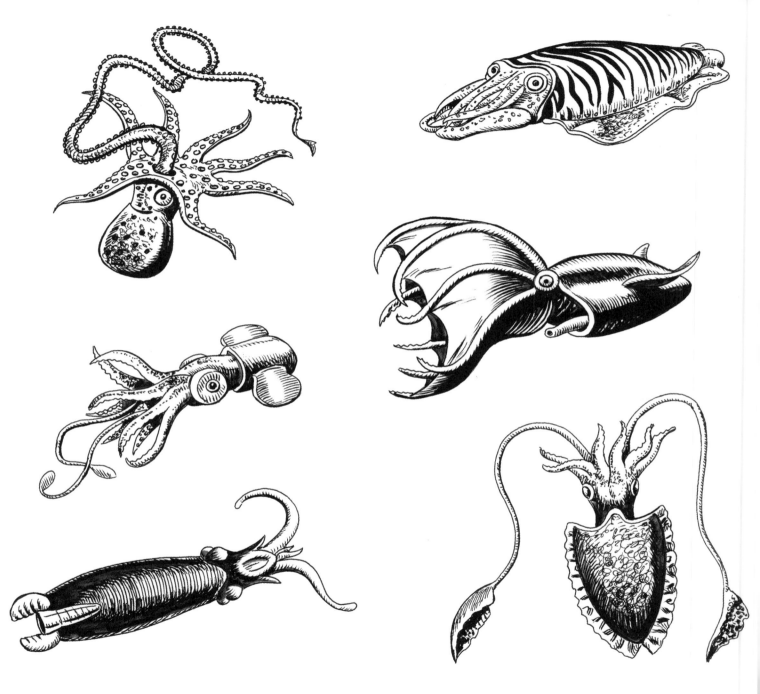

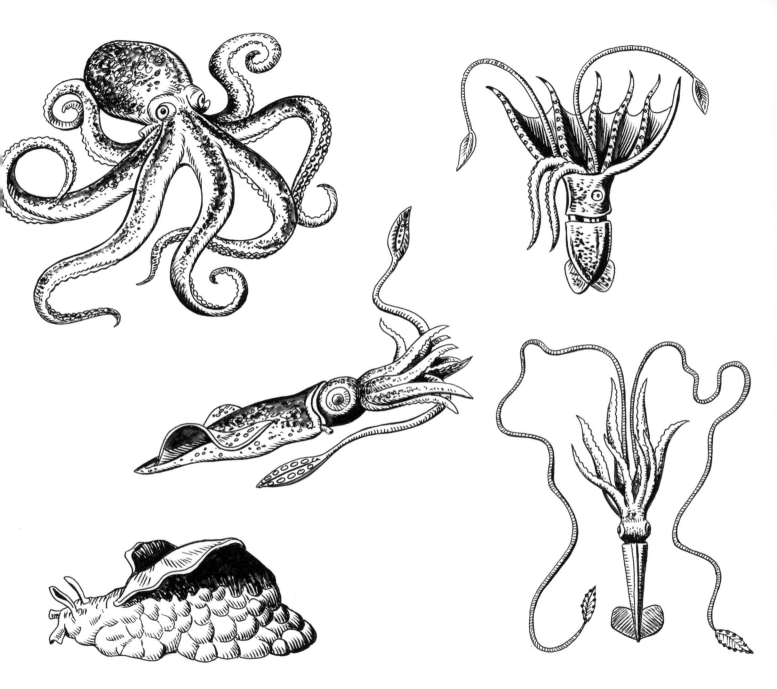

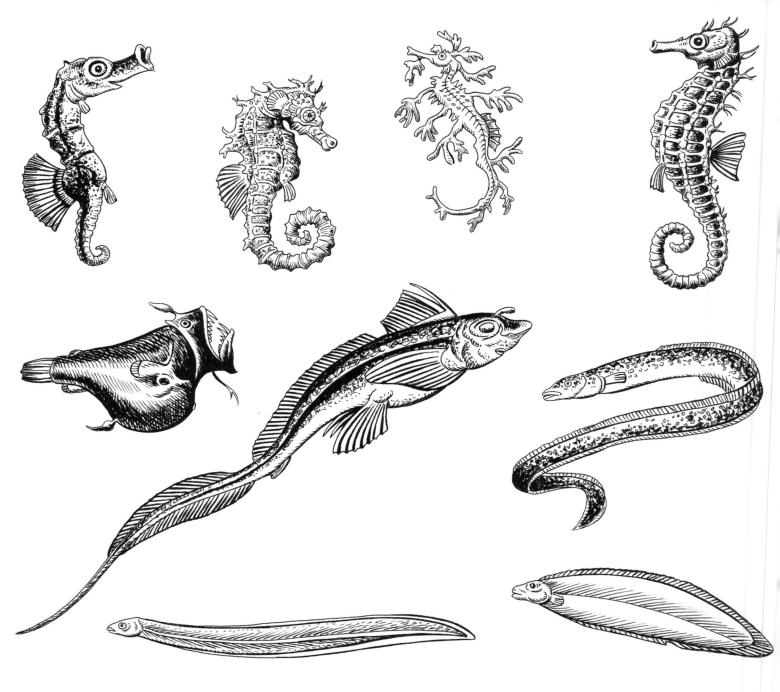

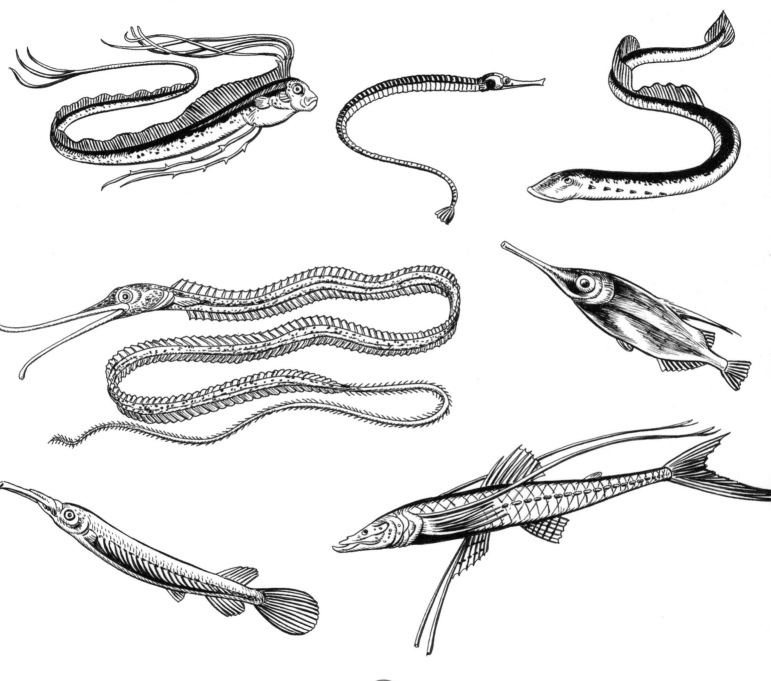

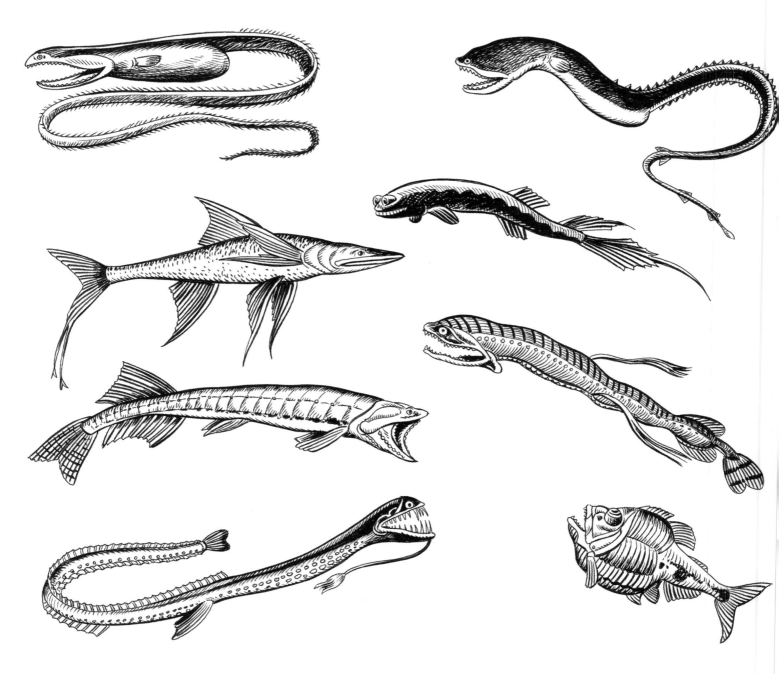

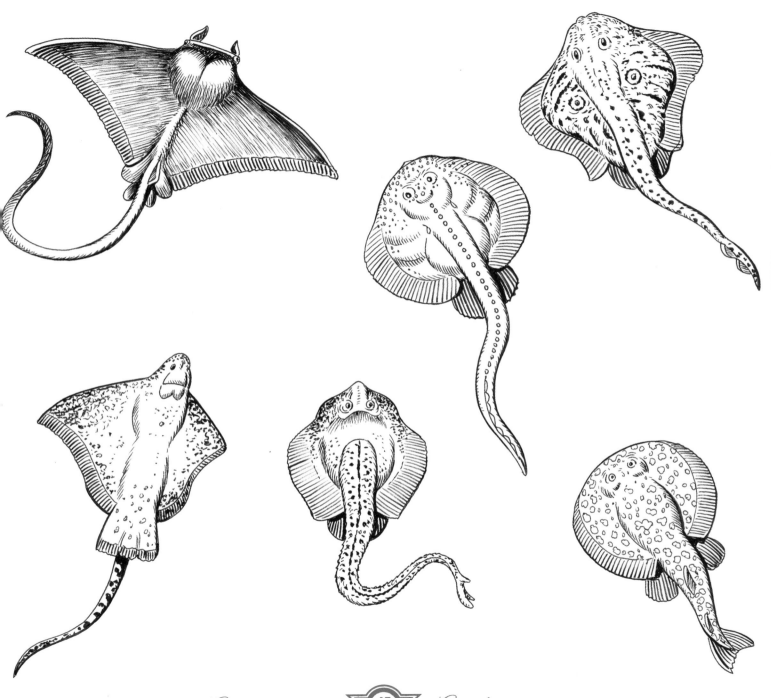

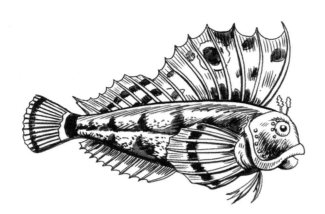
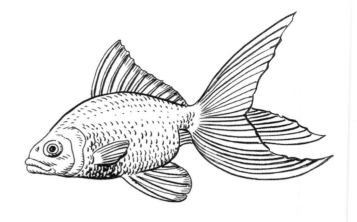
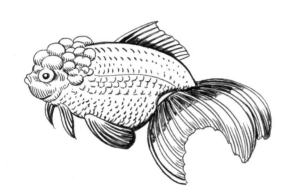
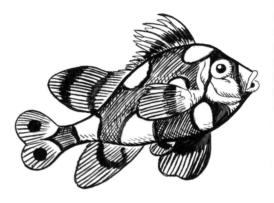
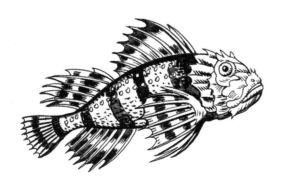
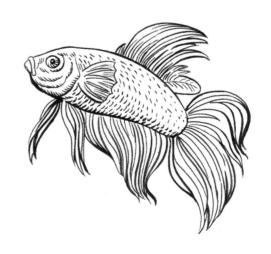

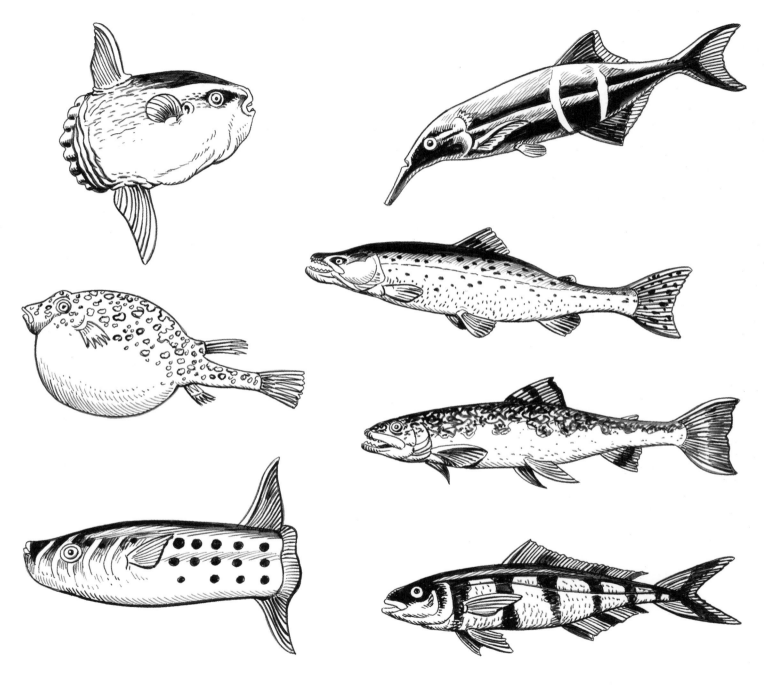

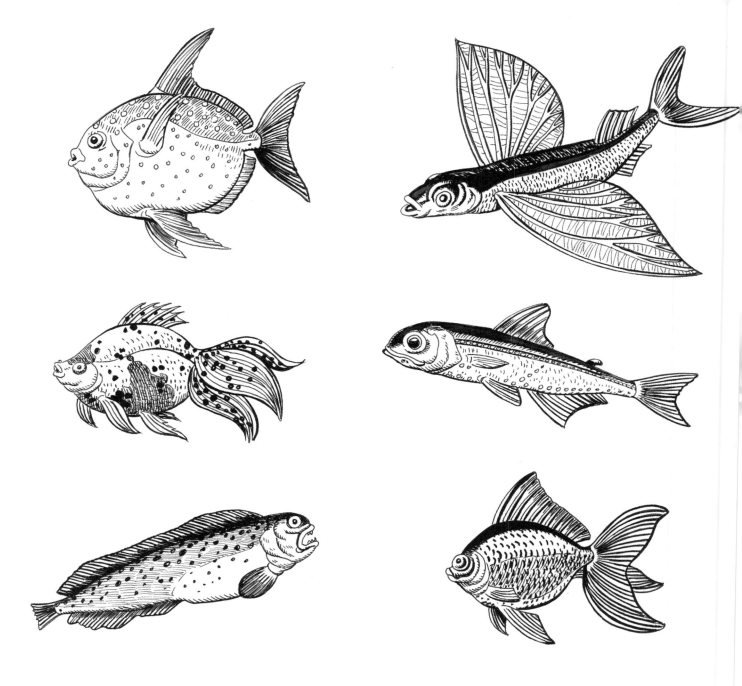

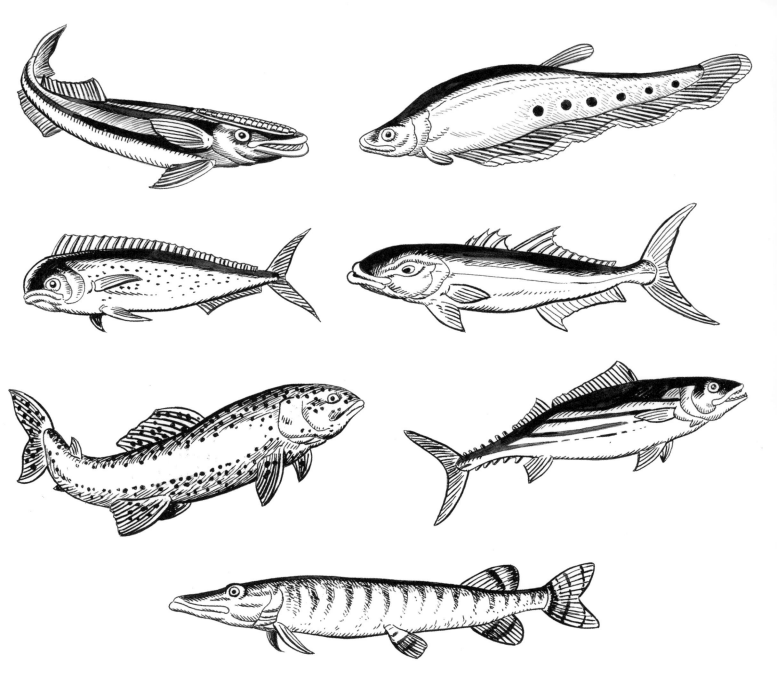

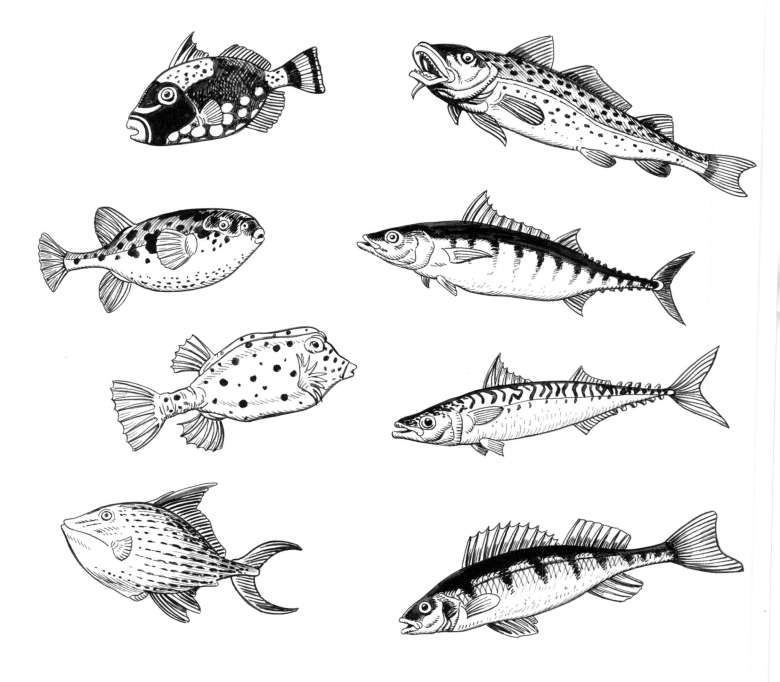

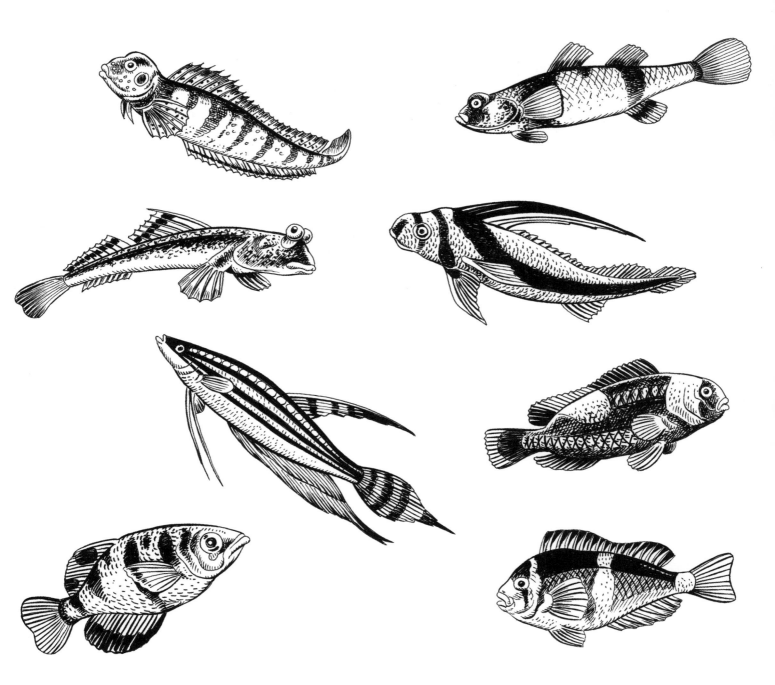

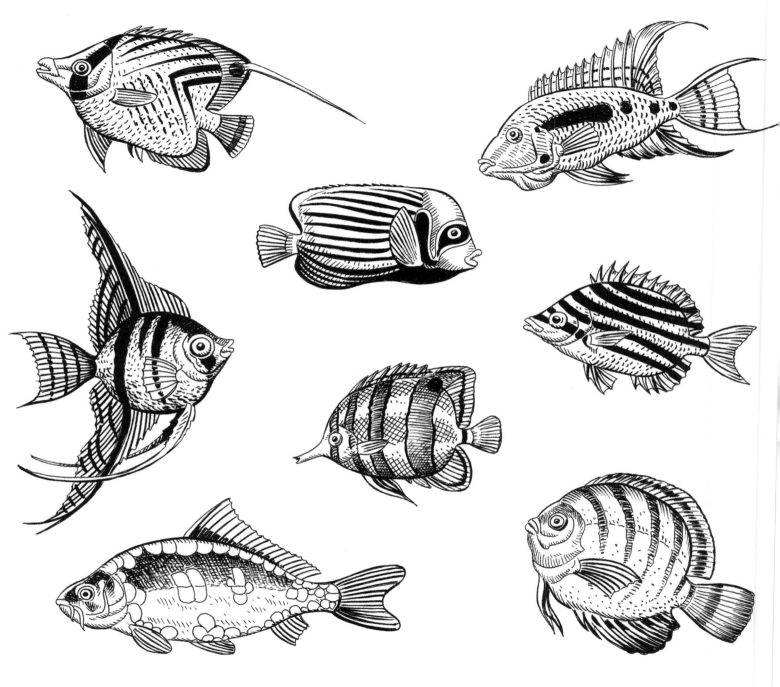

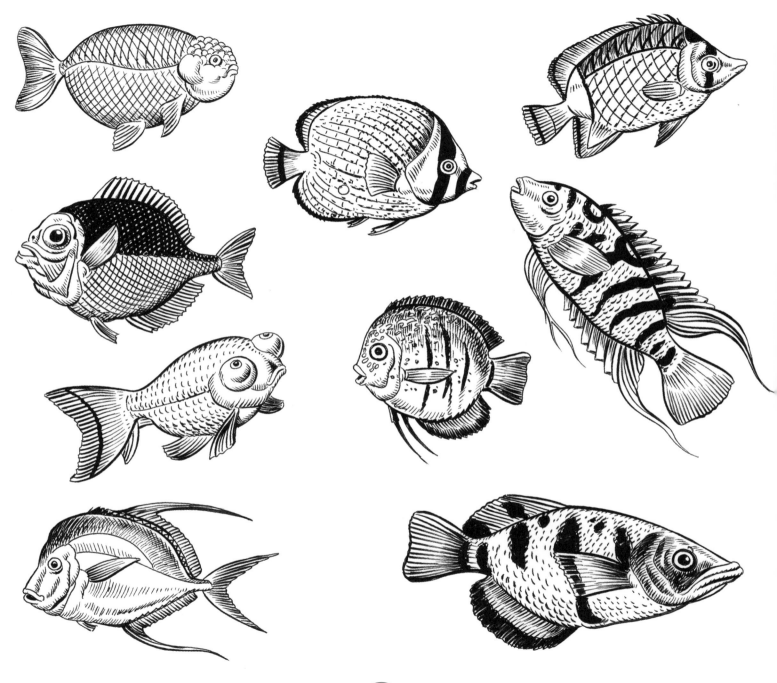

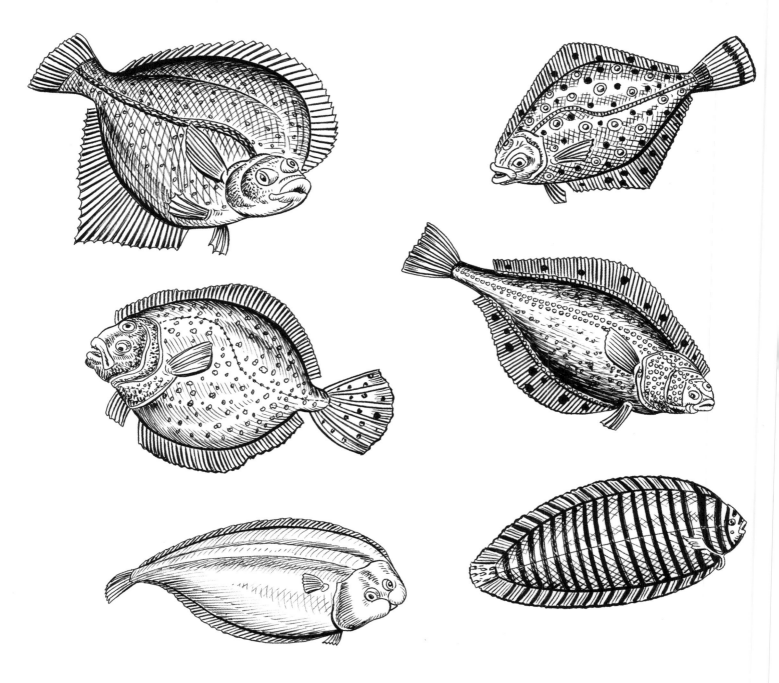

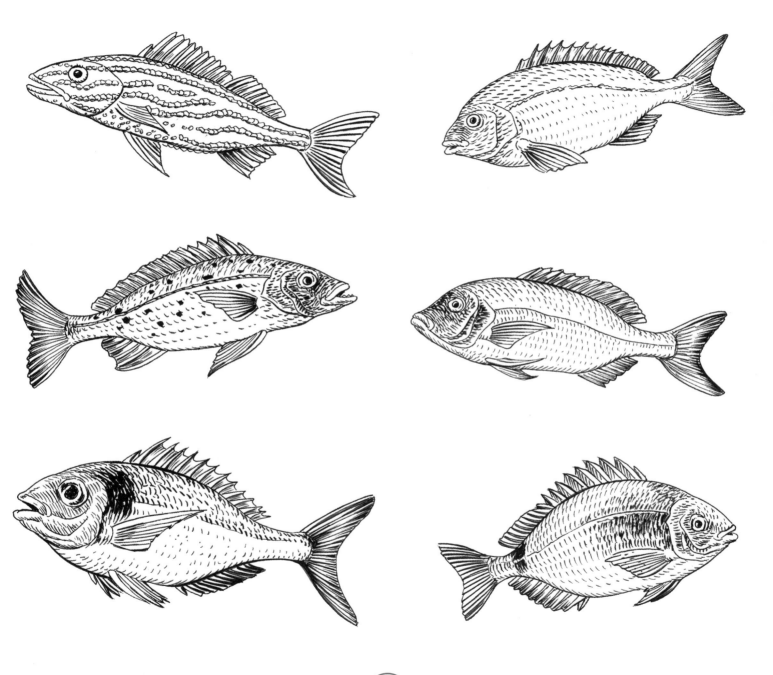

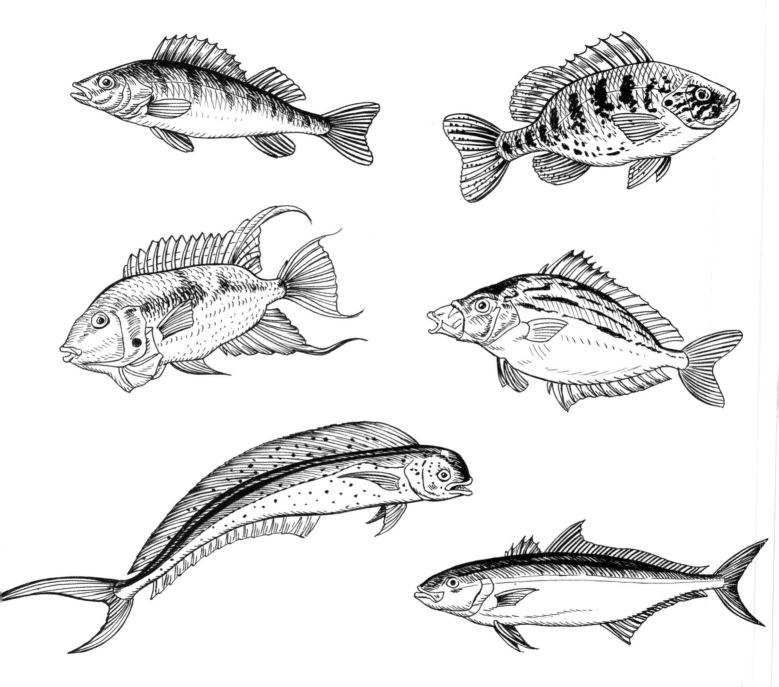

 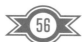

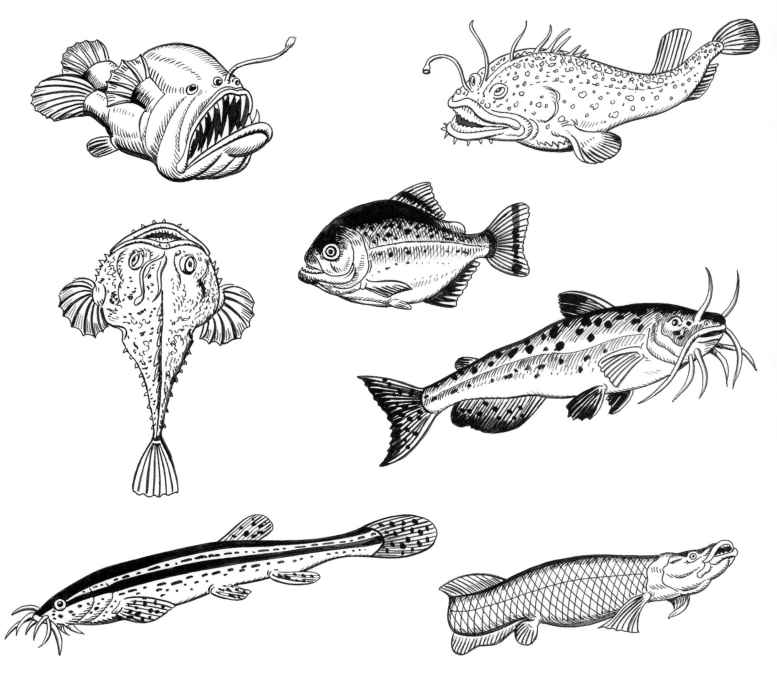

 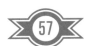

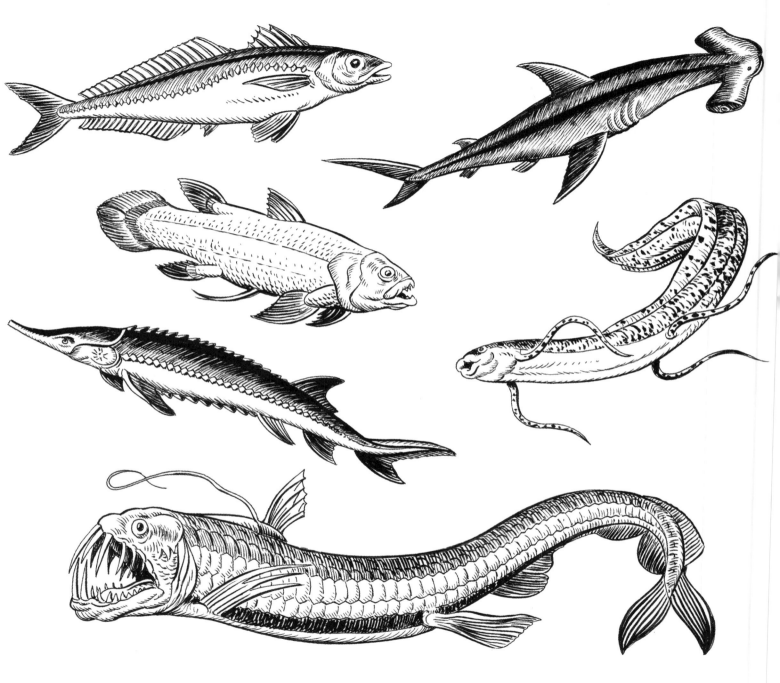

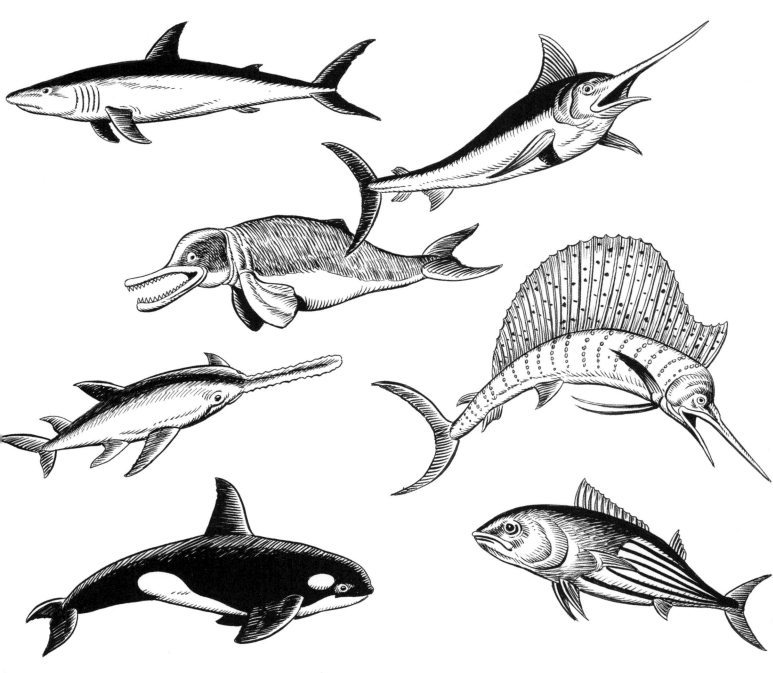

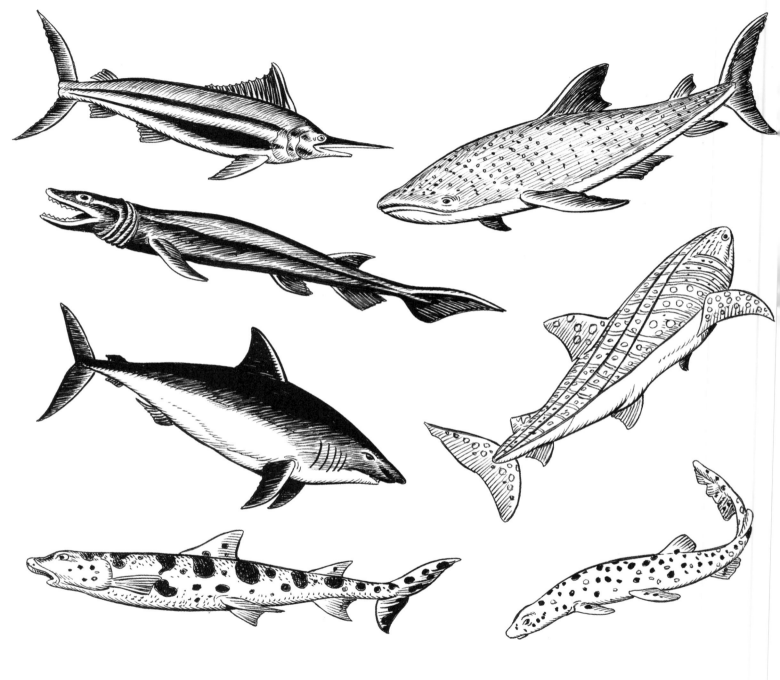

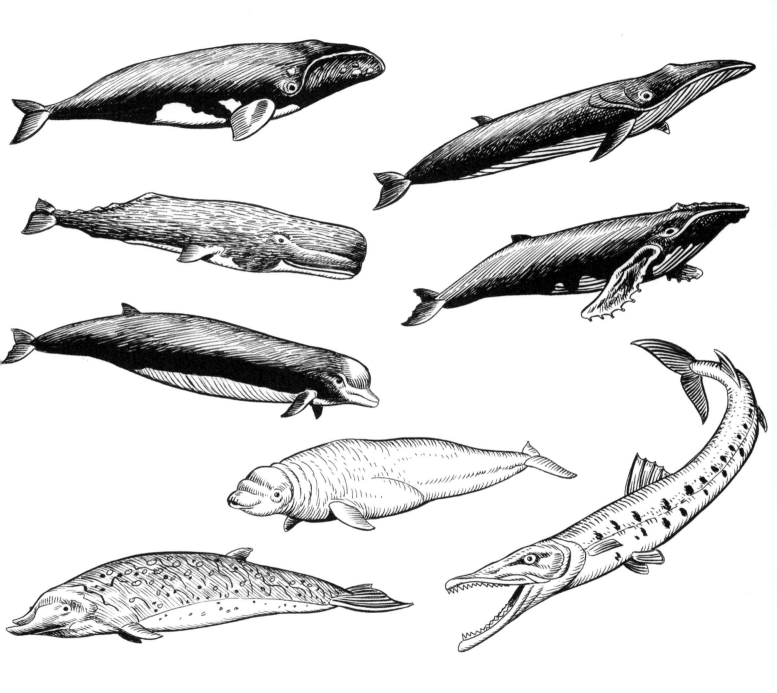

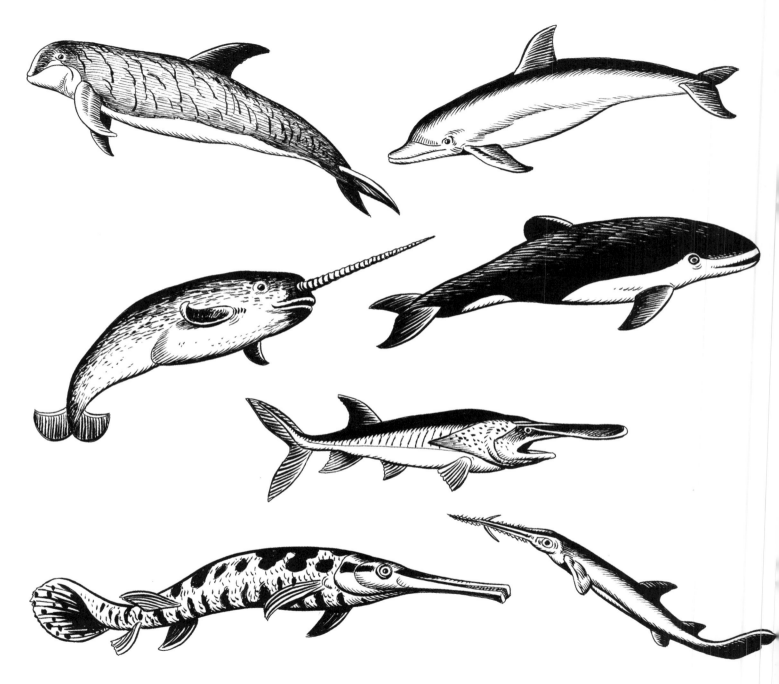

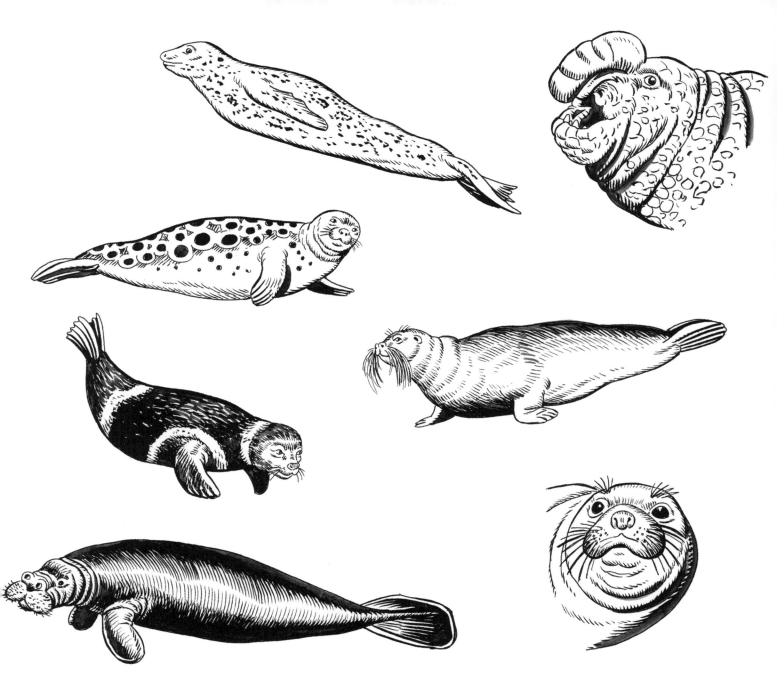

 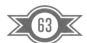

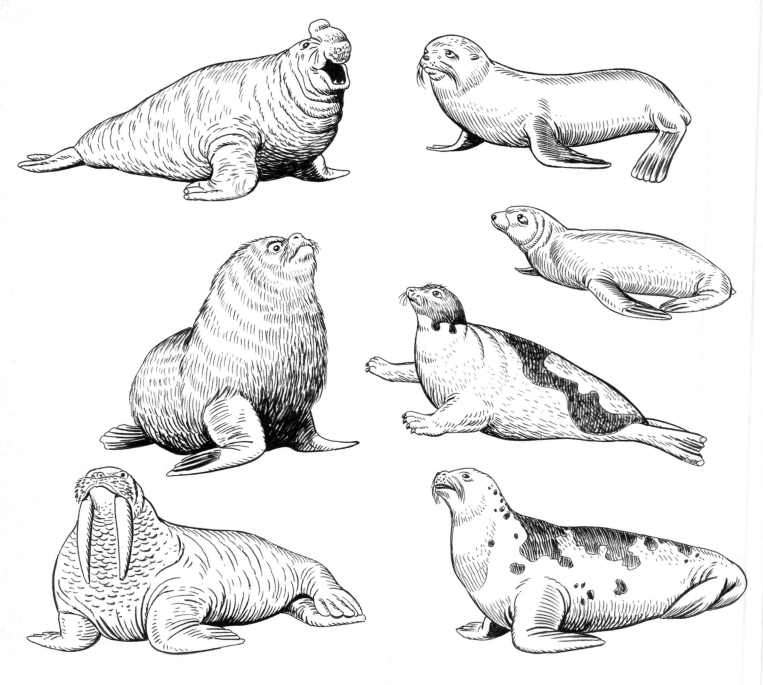

 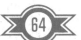

ANIMALS

BIRDS

OISEAUX

AVES

UCCELLI

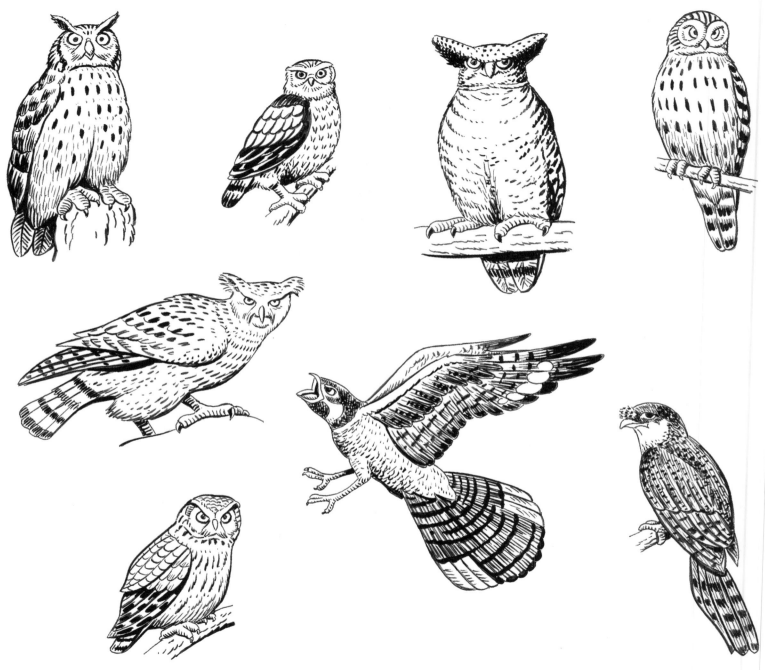

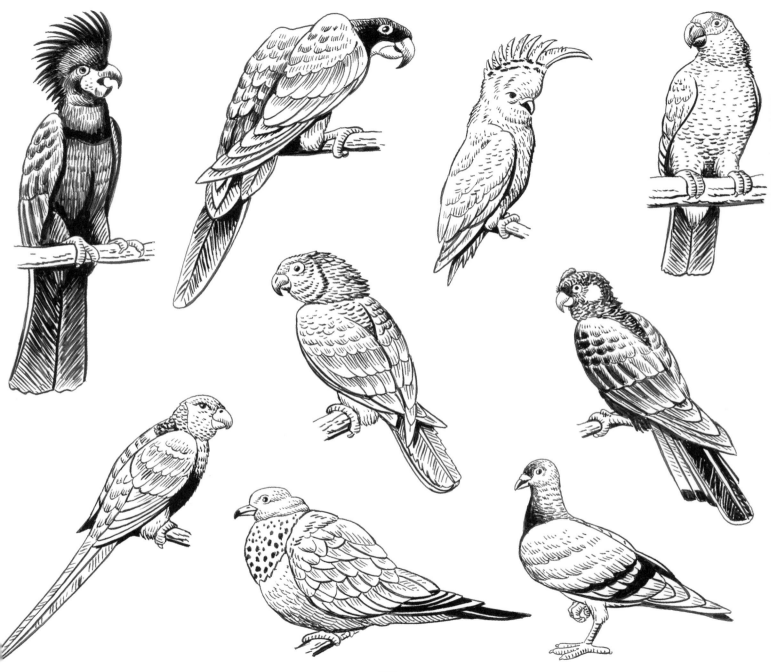

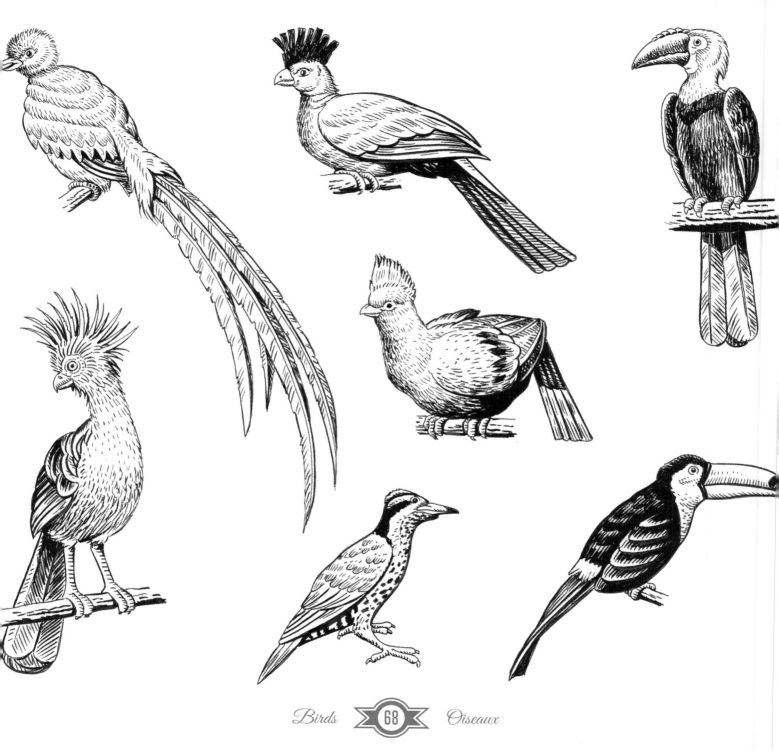

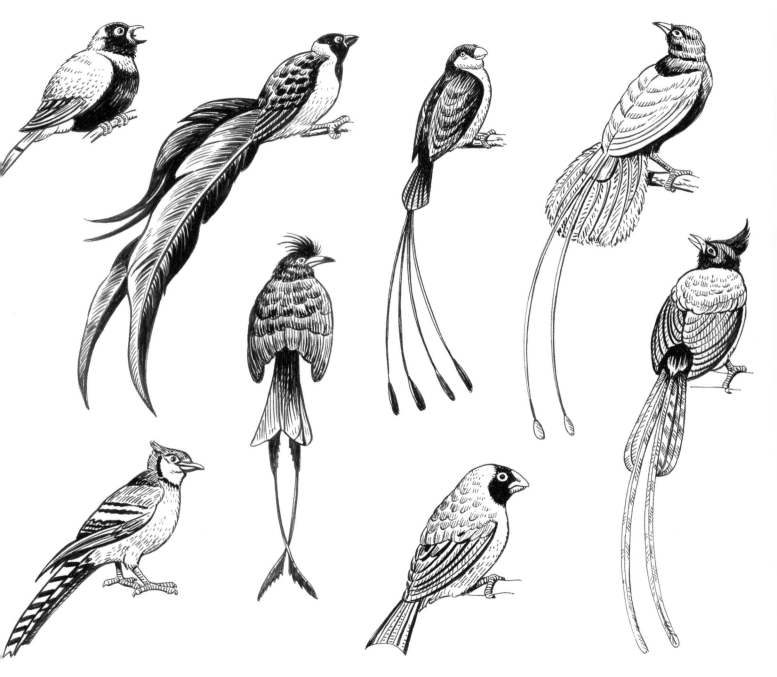

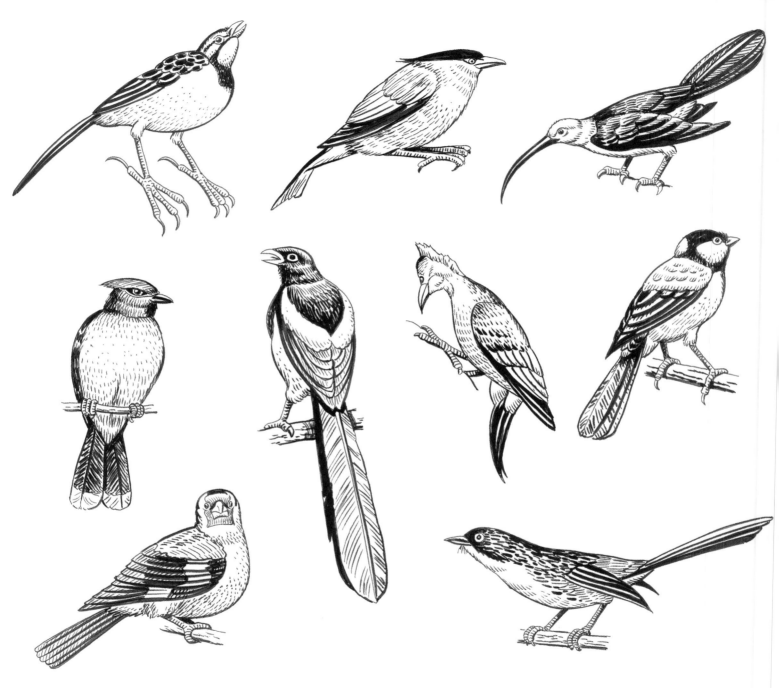

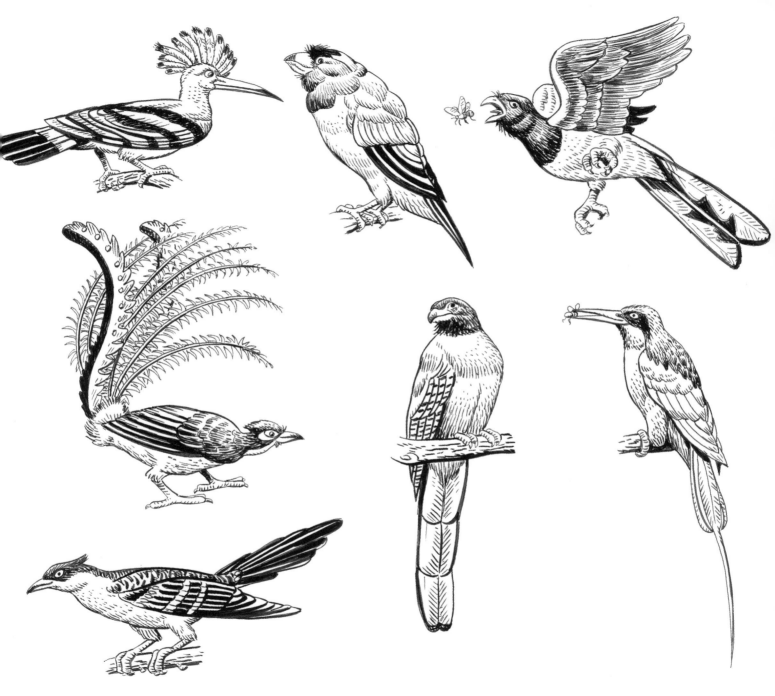

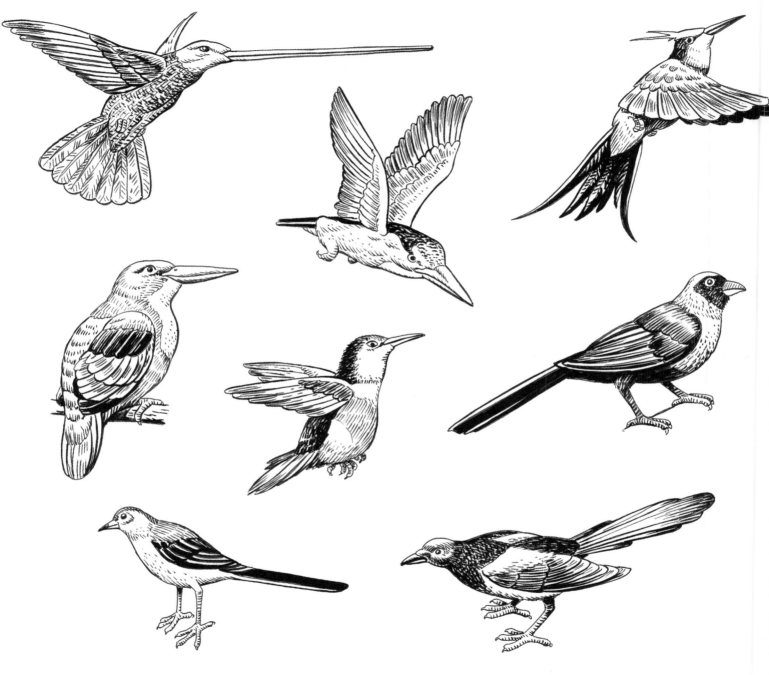

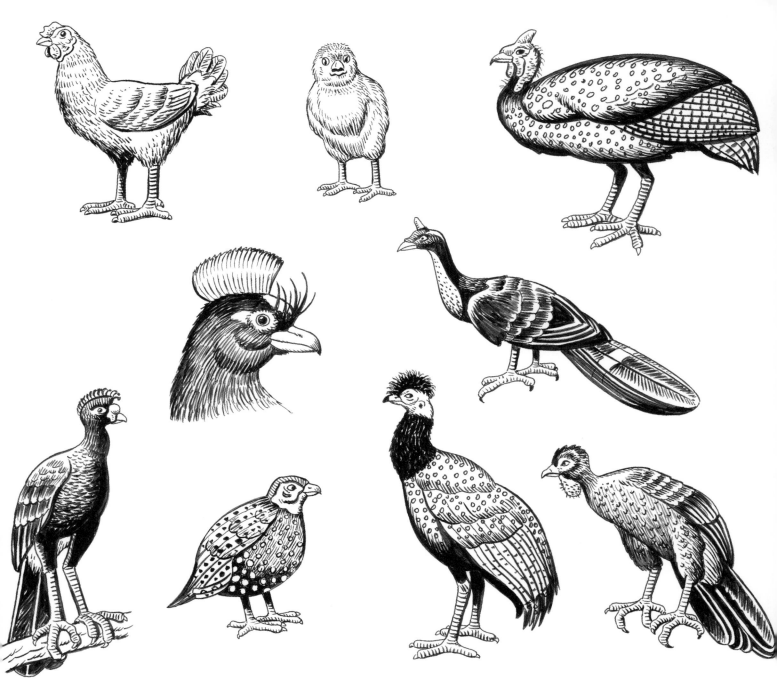

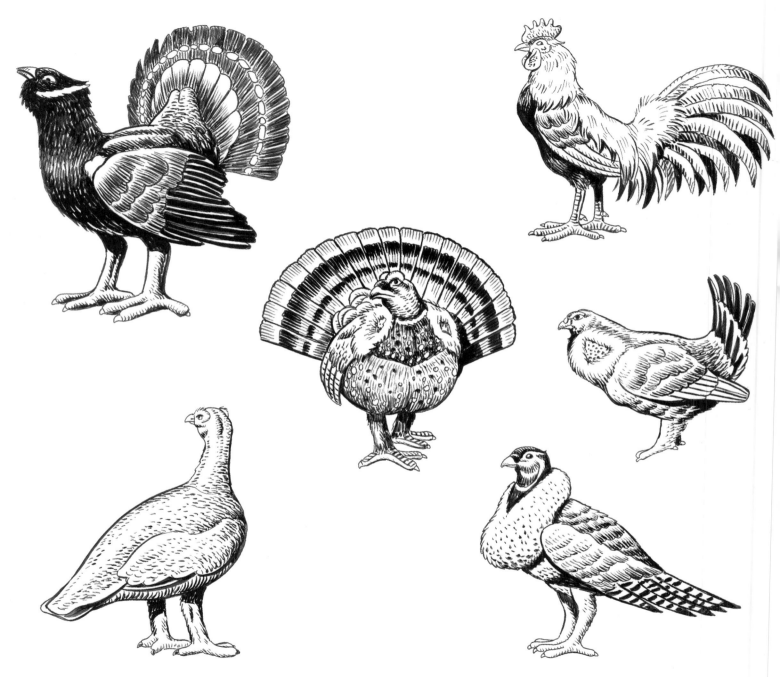

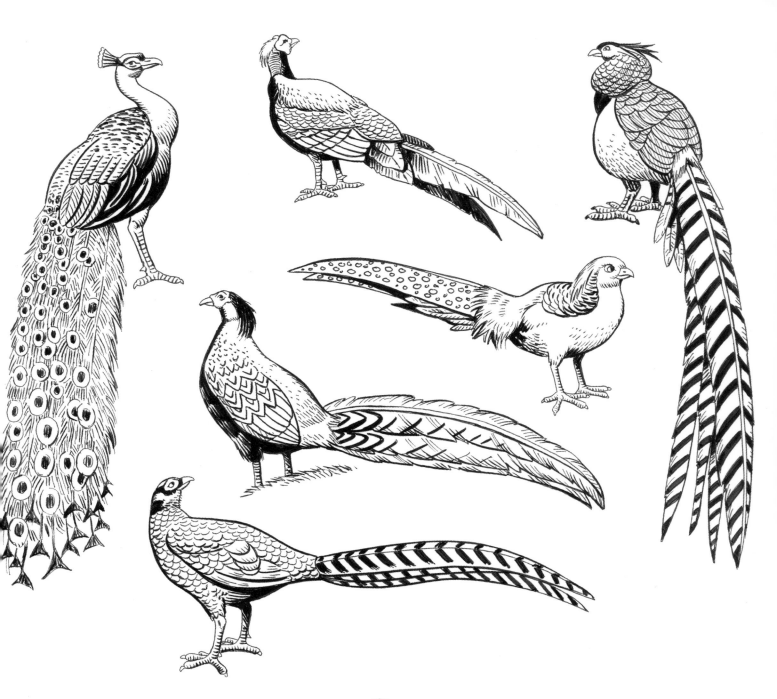

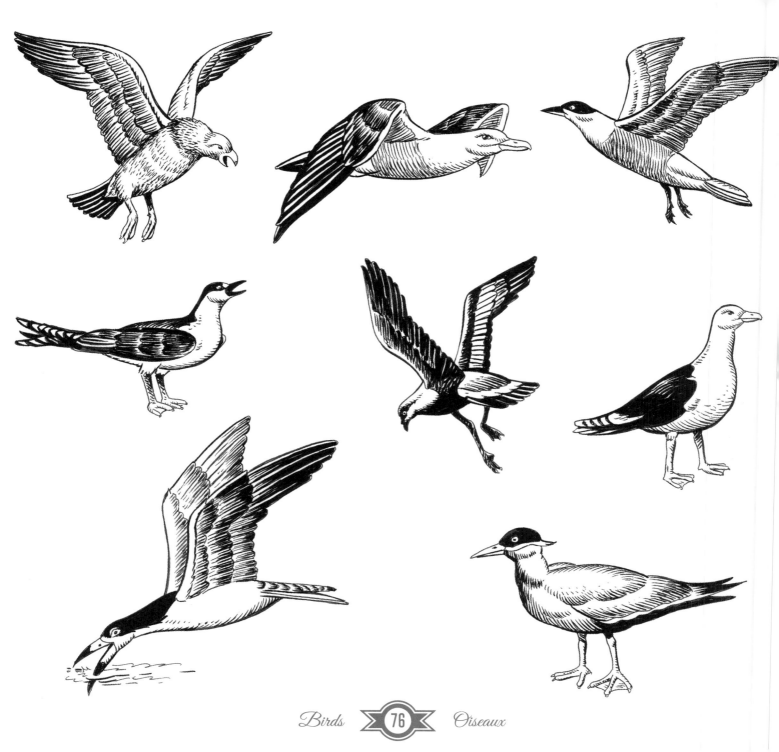

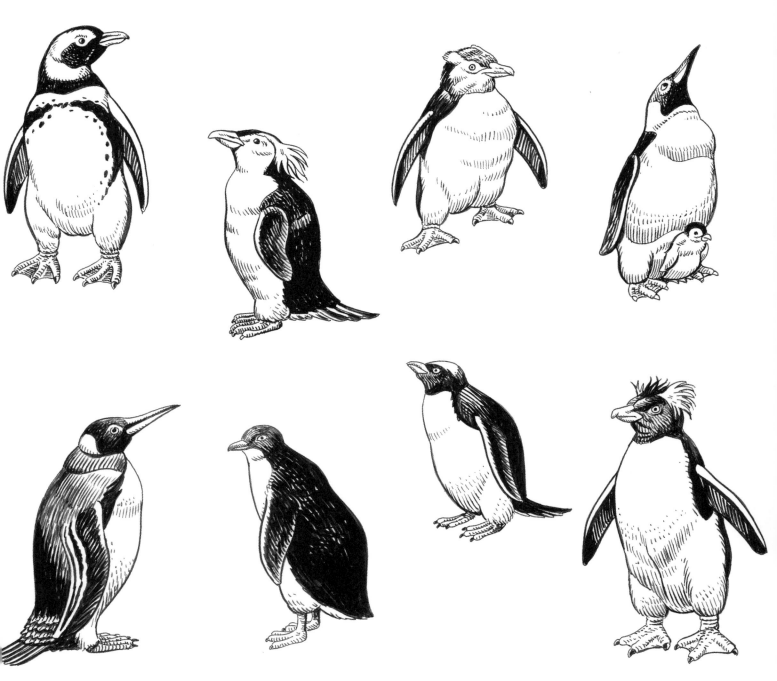

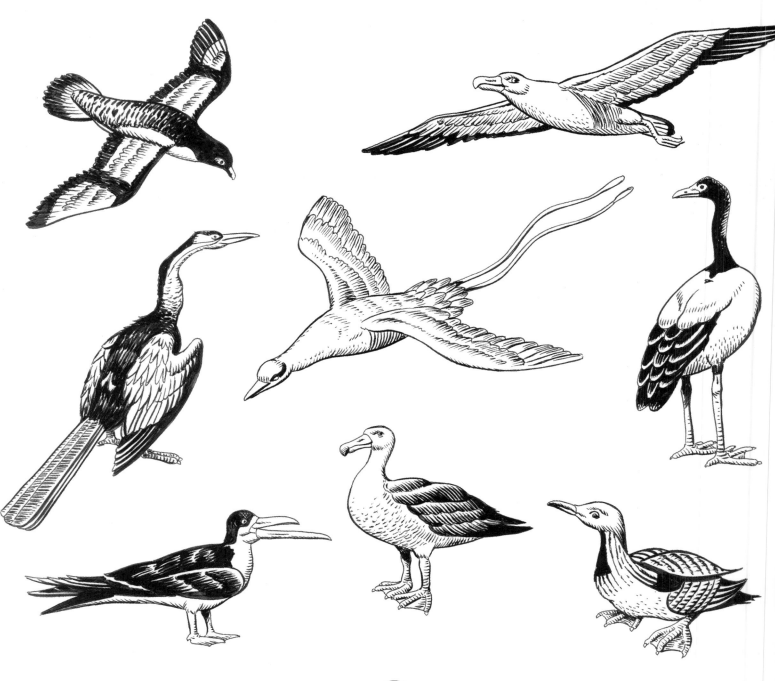

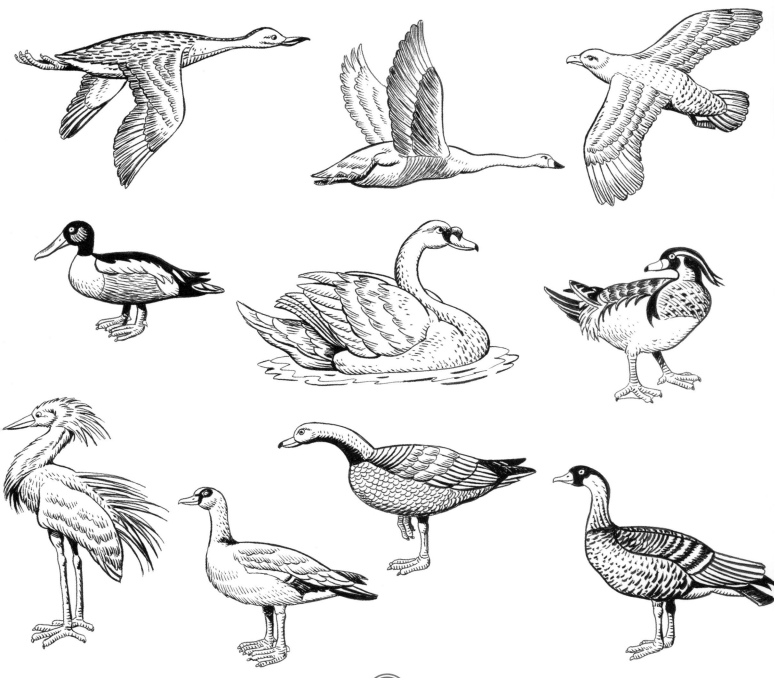

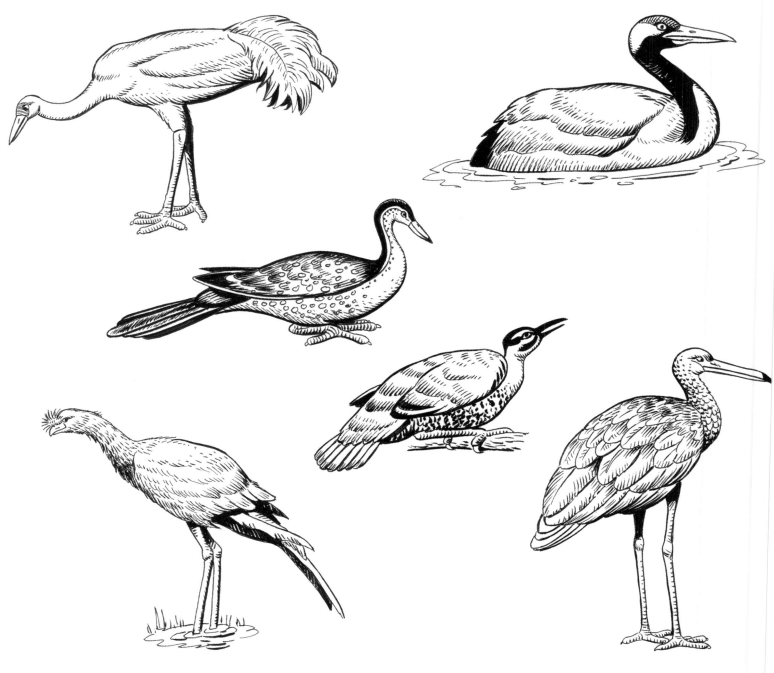

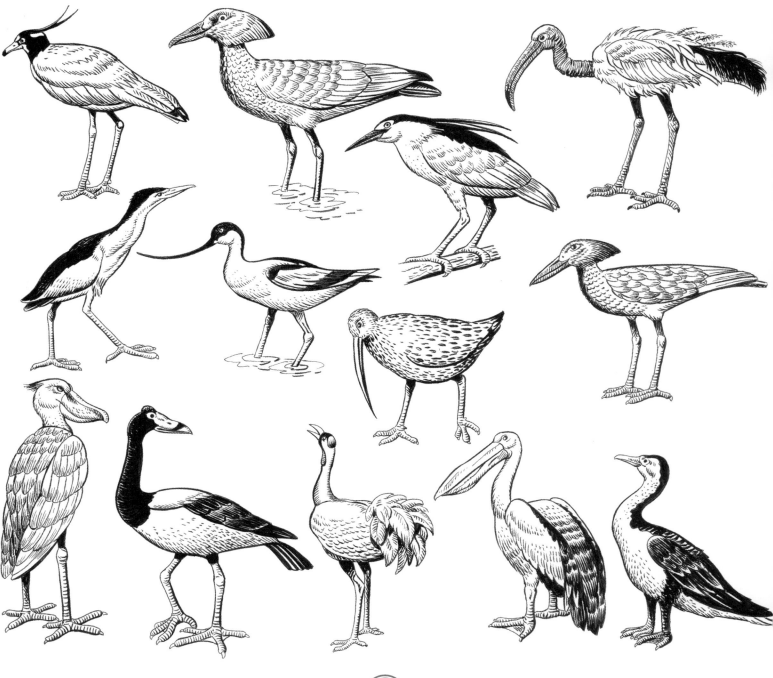

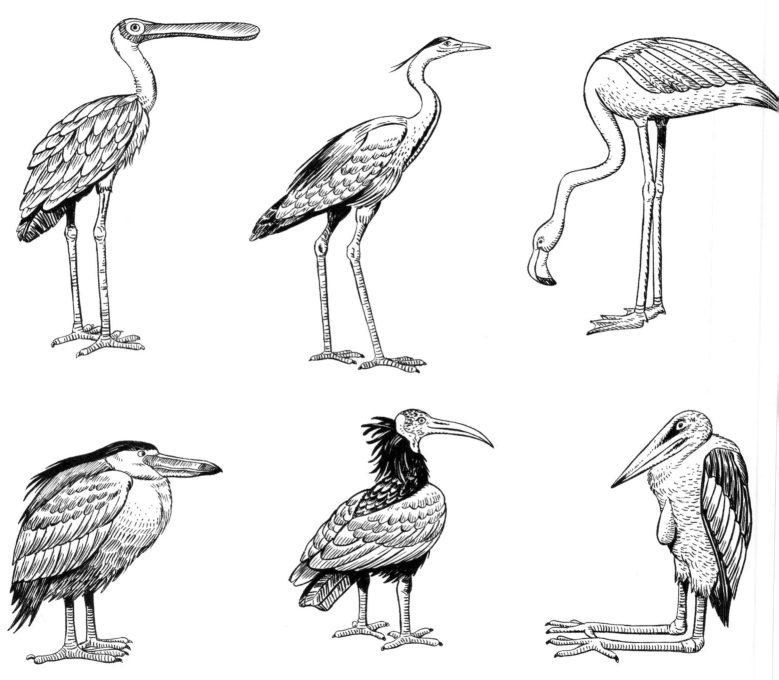

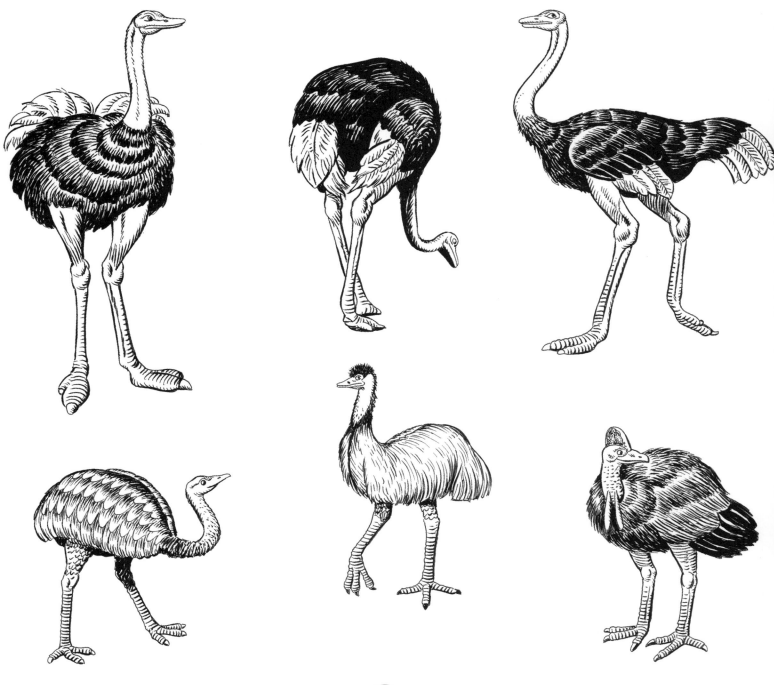

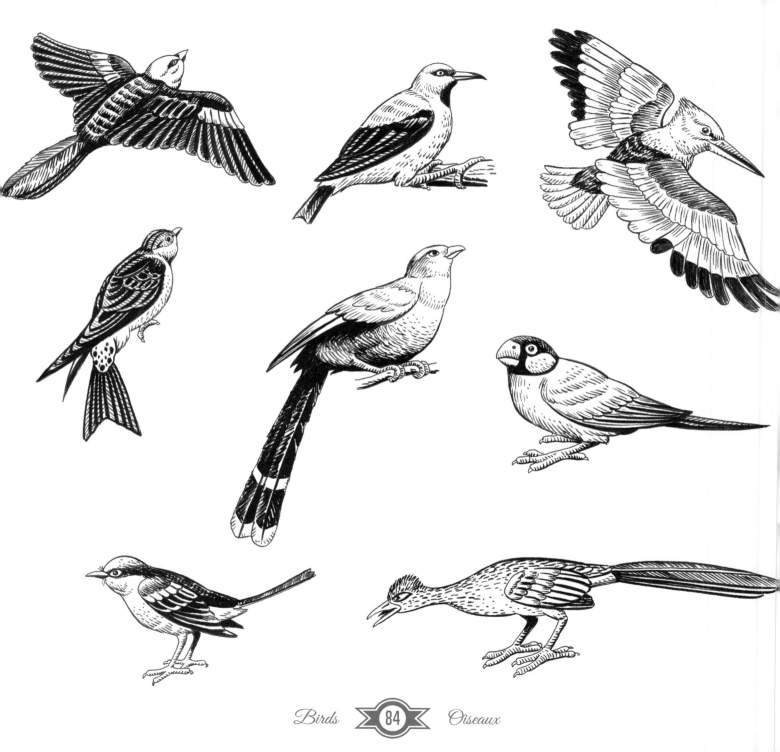

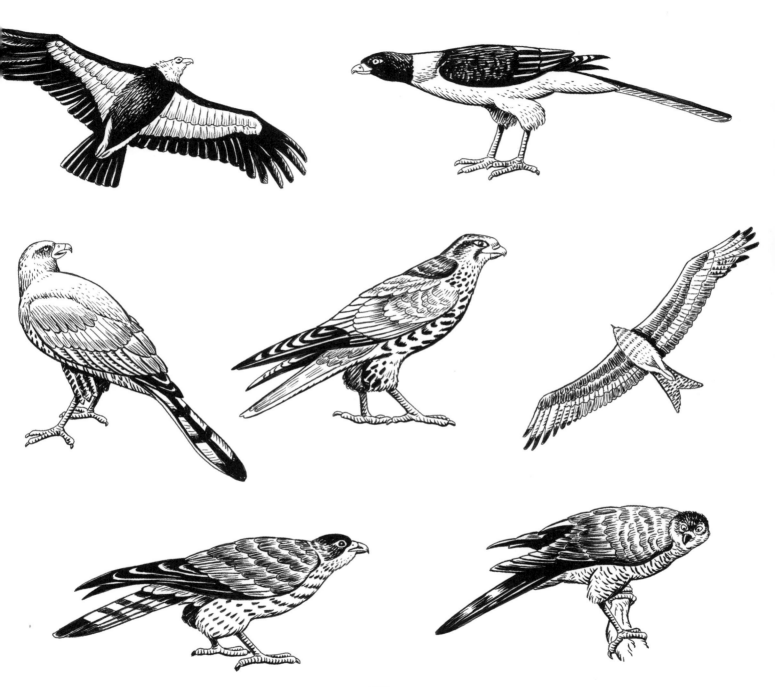

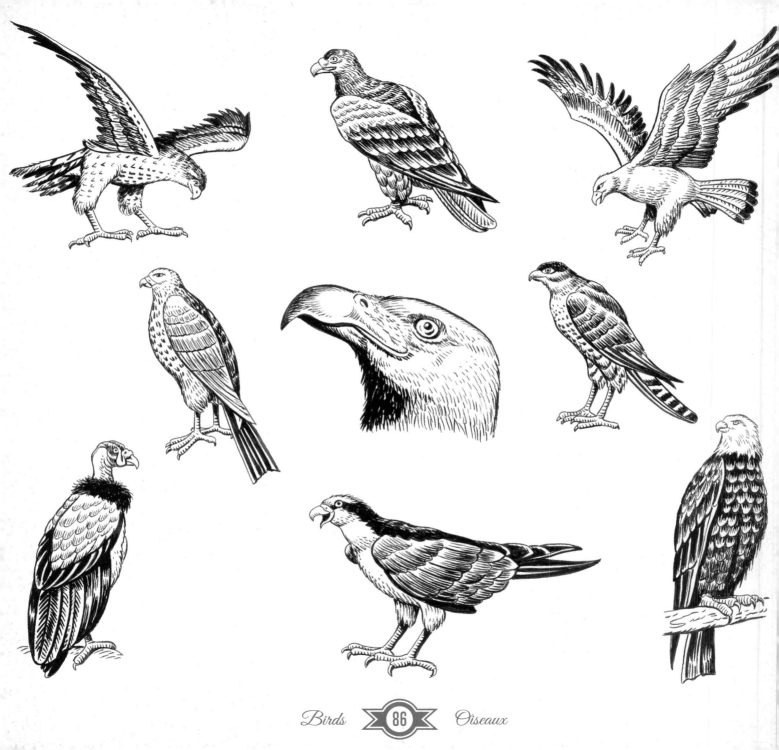

ANIMALS

PETS AND FARM ANIMALS

ANIMAUX DE COMPAGNIE ET DOMESTIQUES

ANIMALES DOMÉSTICOS Y DE GRANJA

ANIMALI DOMESTICI E DI ALLEVAMENTO

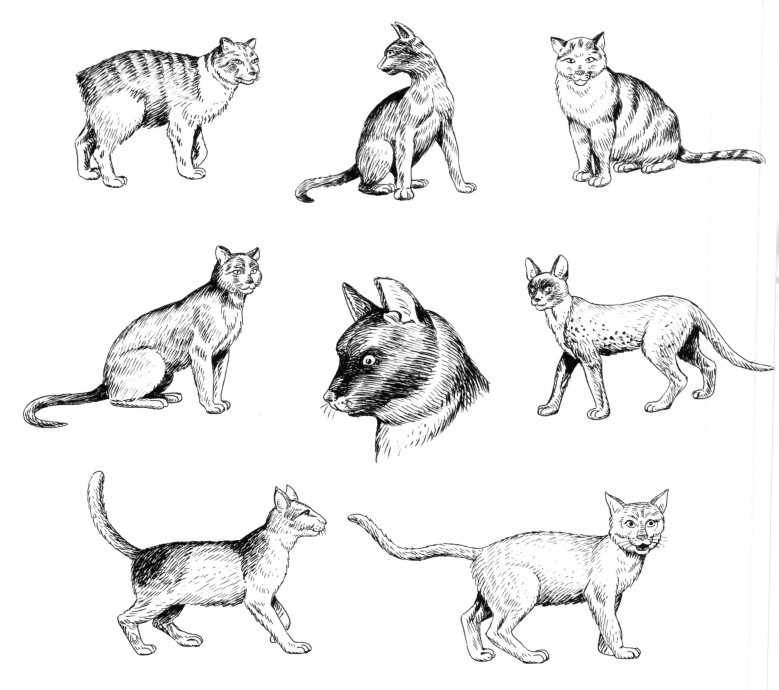

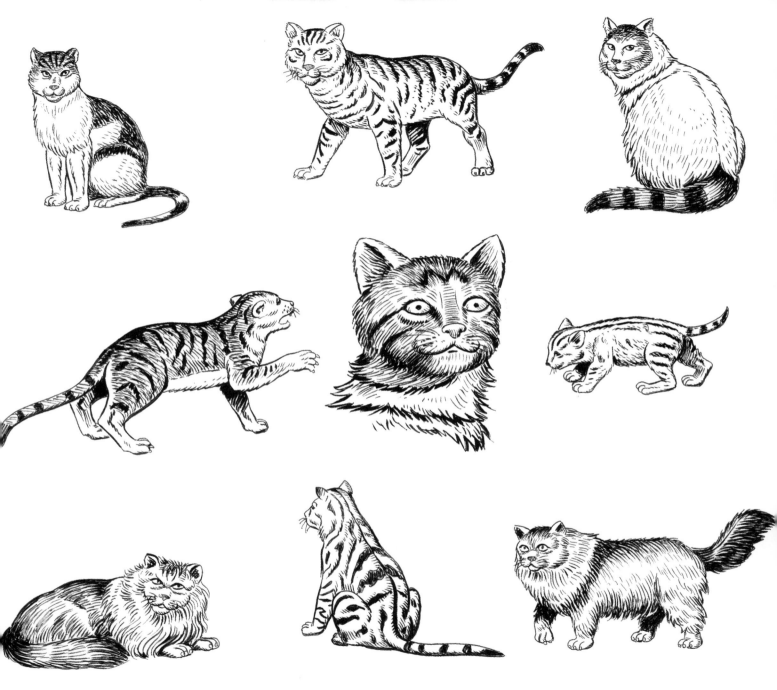

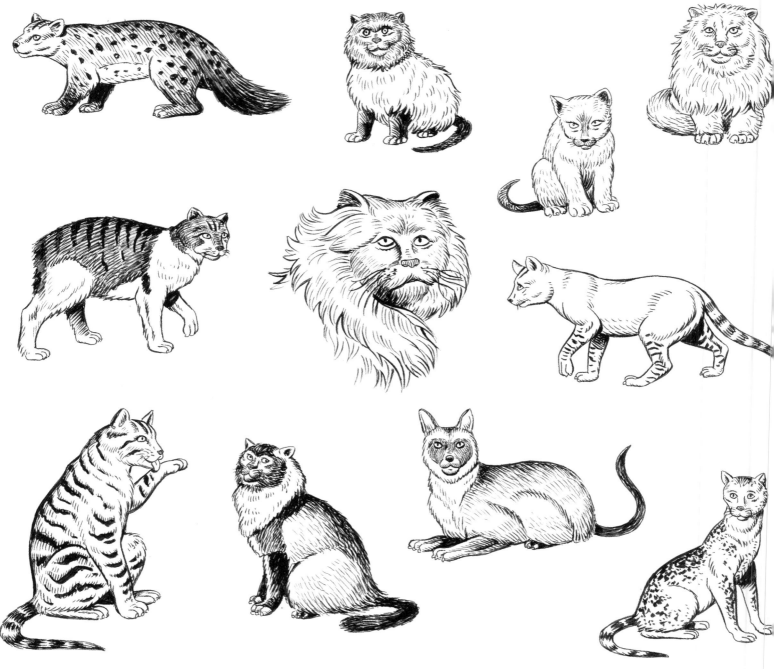

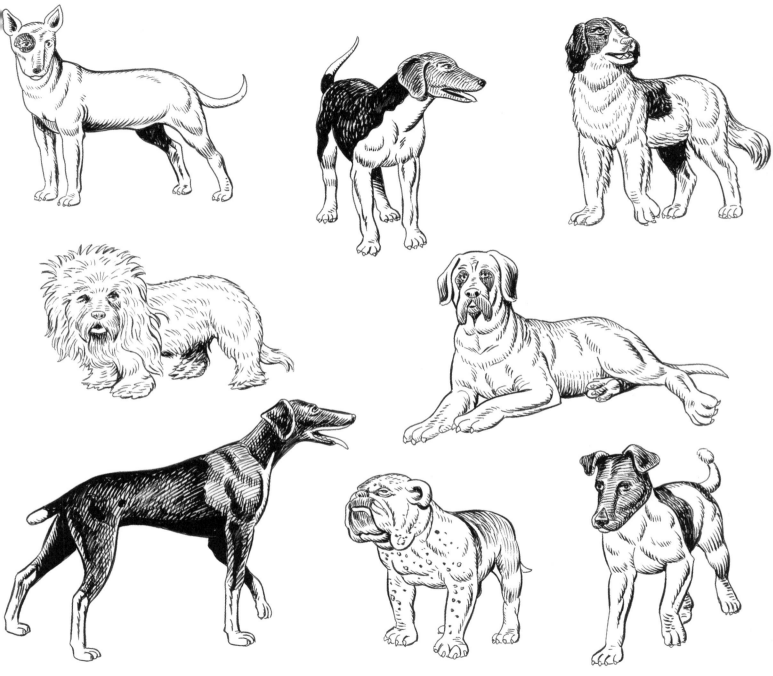

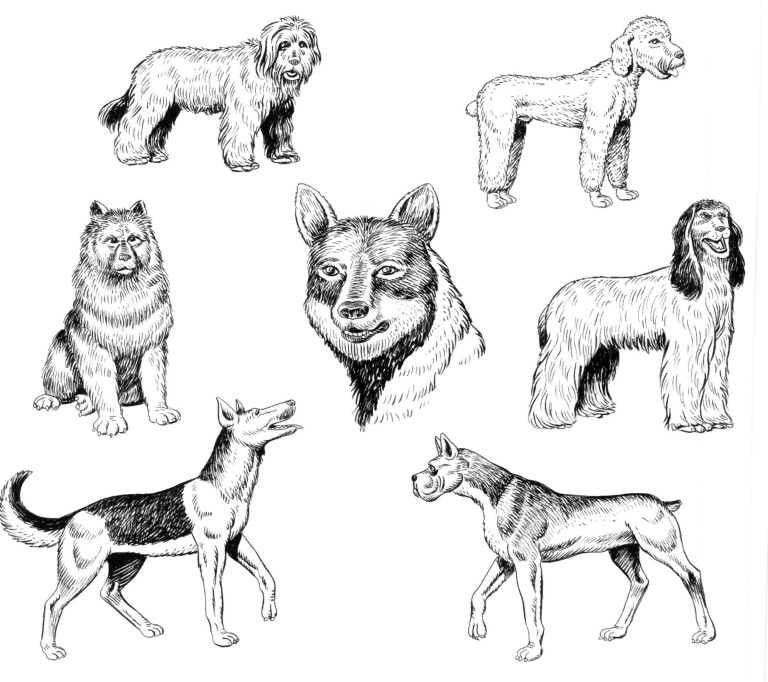

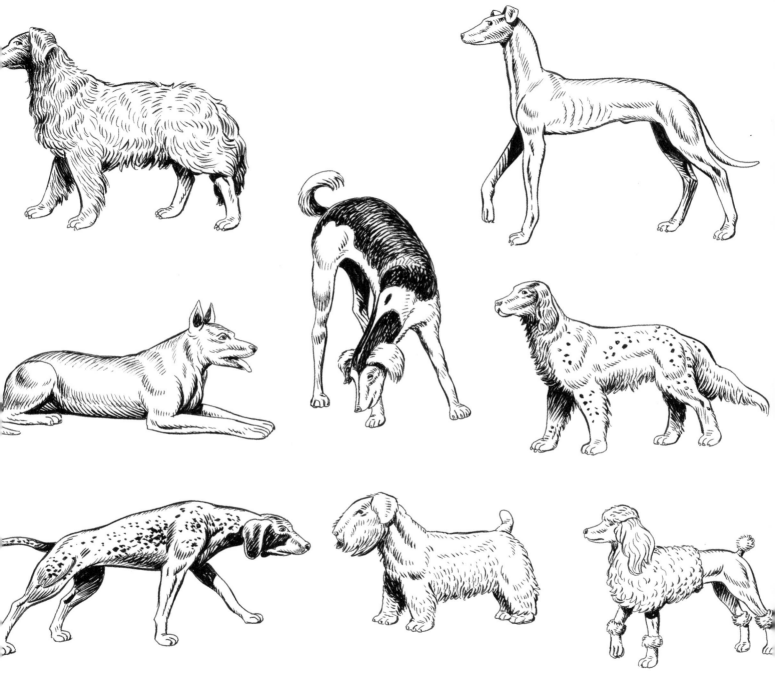

 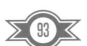

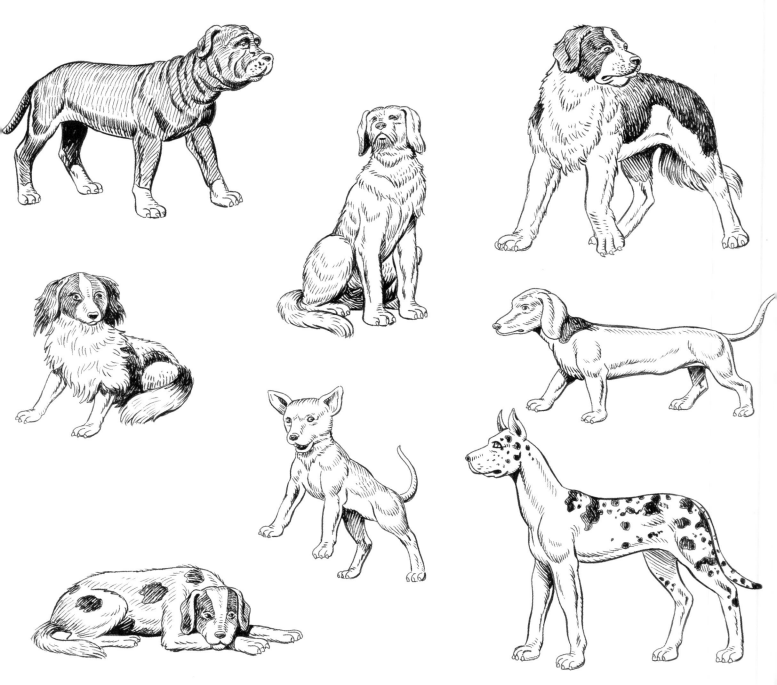

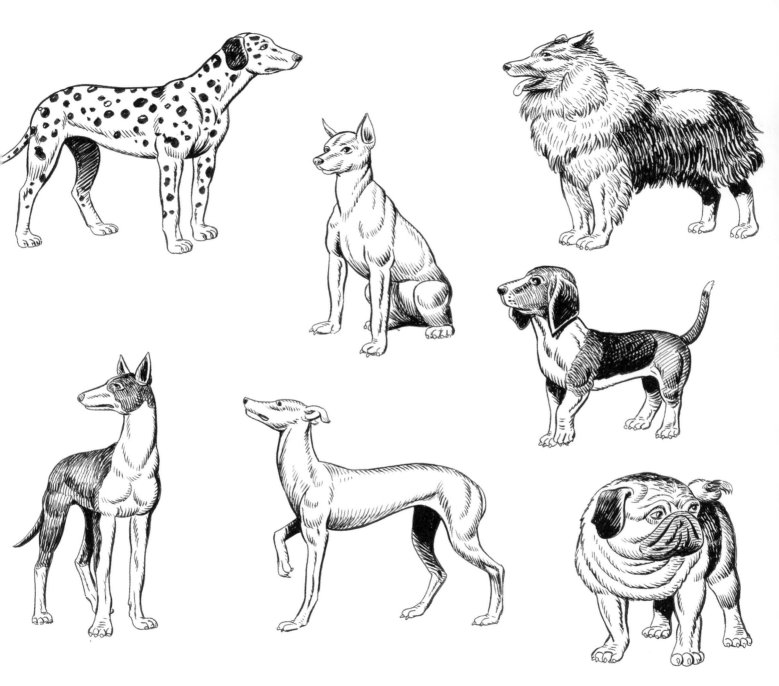

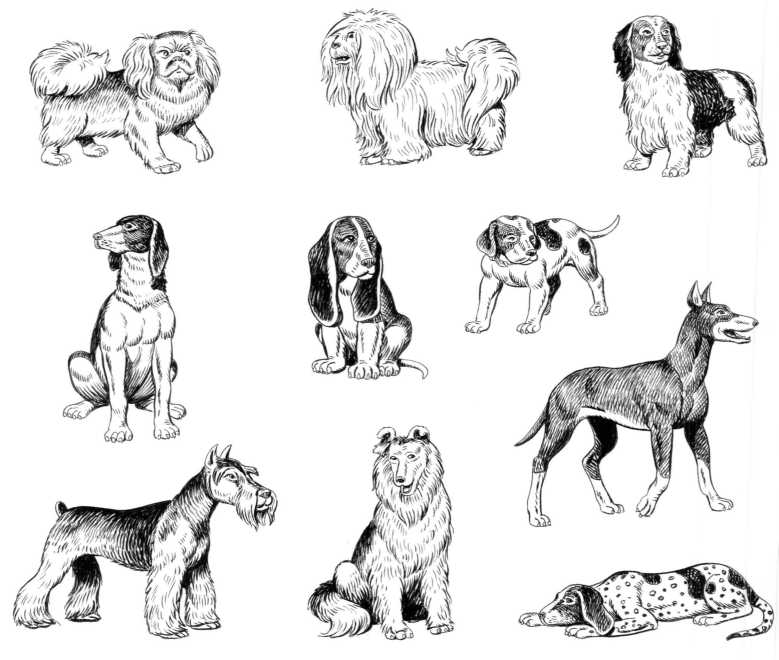

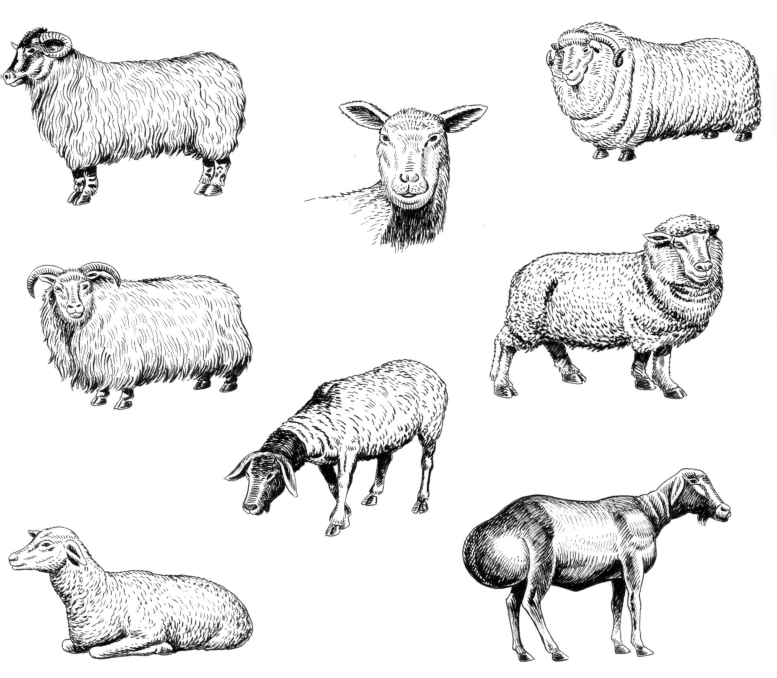

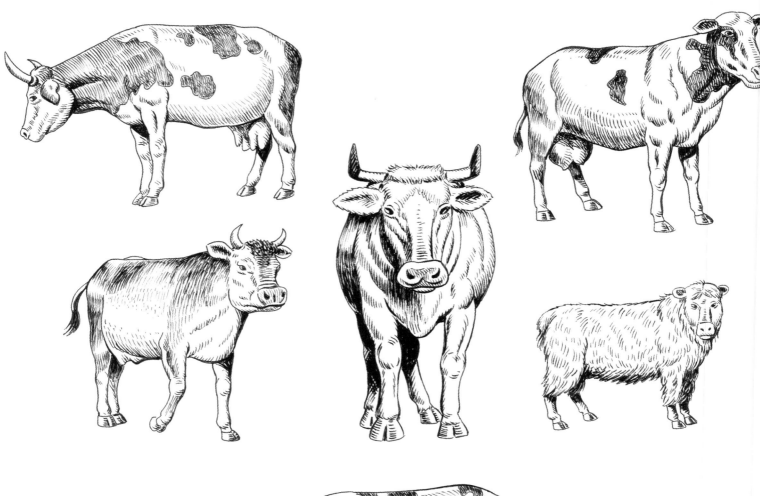

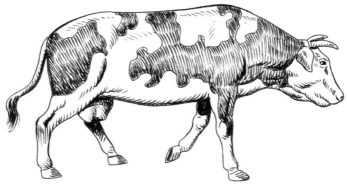

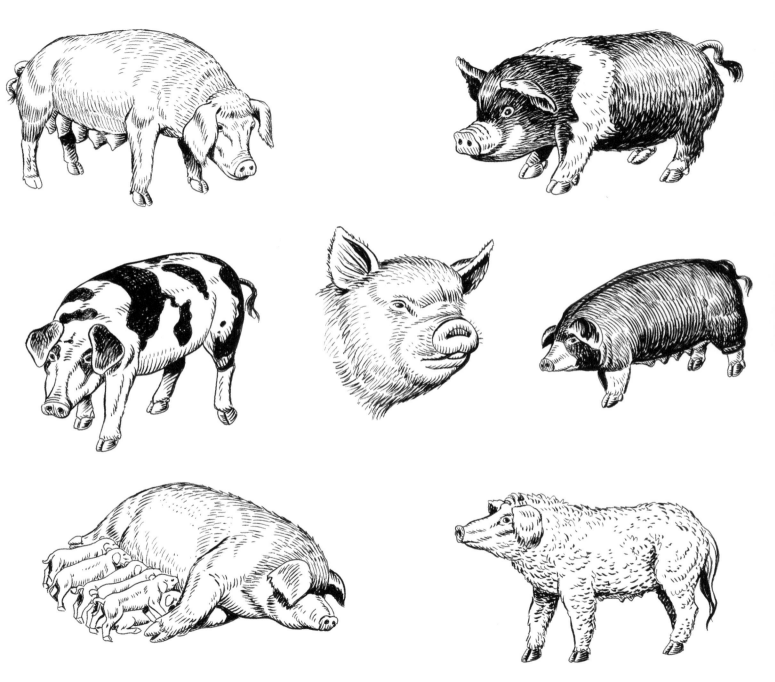

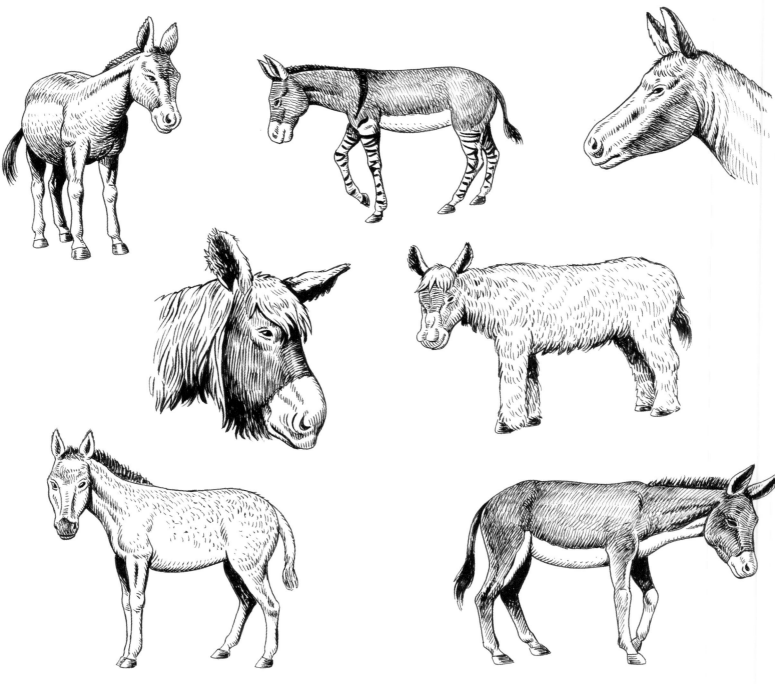

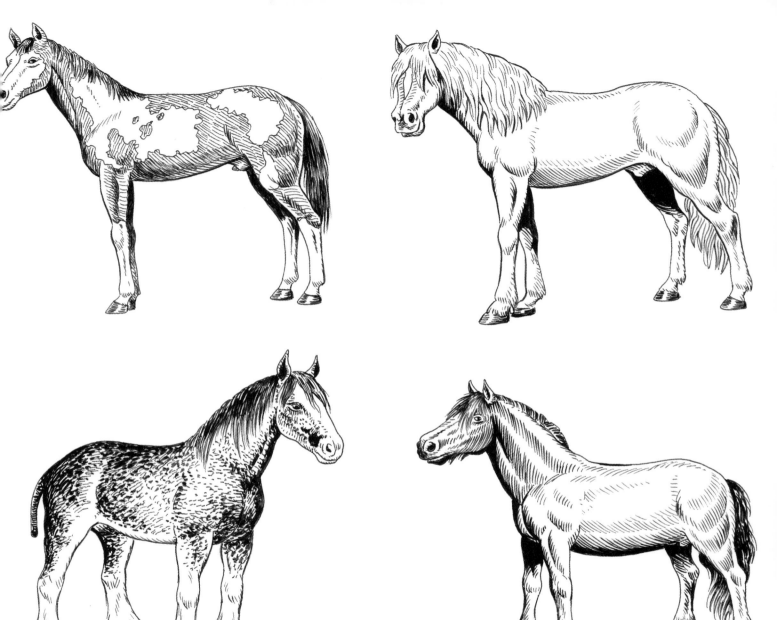

 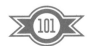

 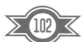

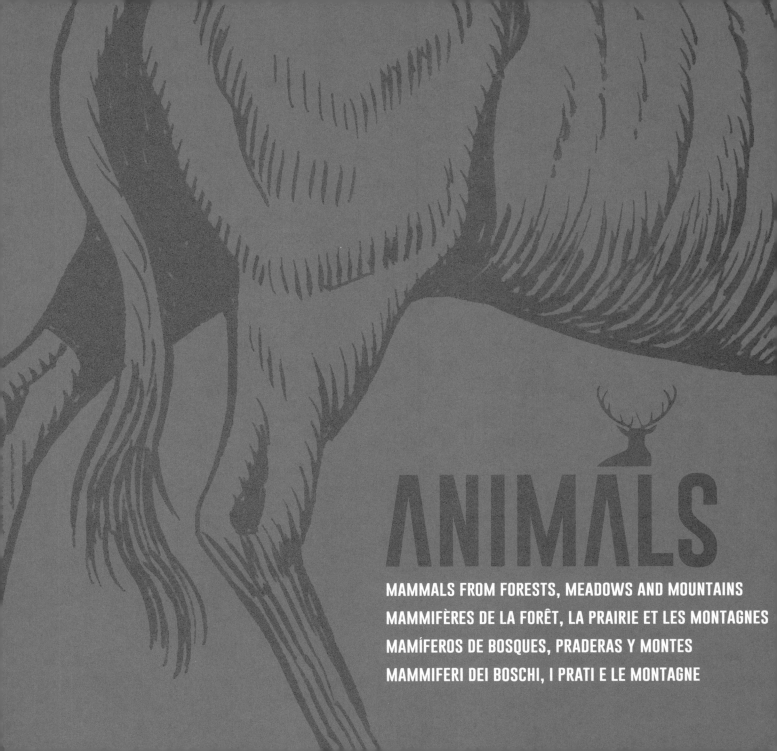

ANIMALS

MAMMALS FROM FORESTS, MEADOWS AND MOUNTAINS

MAMMIFÈRES DE LA FORÊT, LA PRAIRIE ET LES MONTAGNES

MAMÍFEROS DE BOSQUES, PRADERAS Y MONTES

MAMMIFERI DEI BOSCHI, I PRATI E LE MONTAGNE

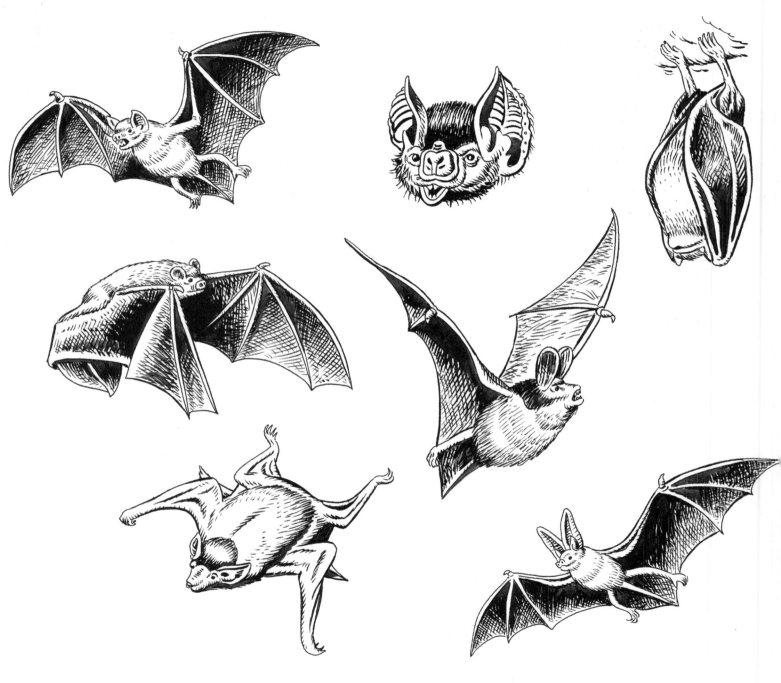

 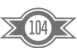

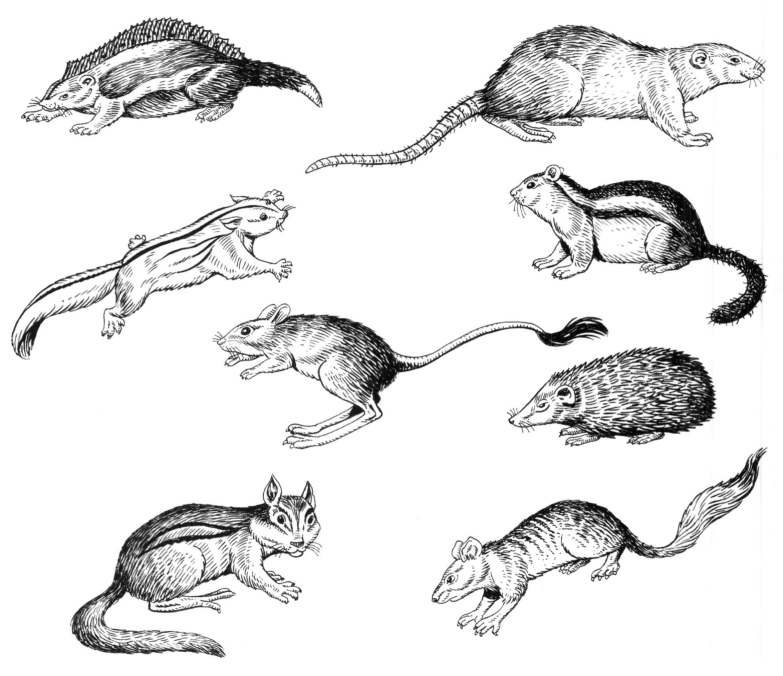

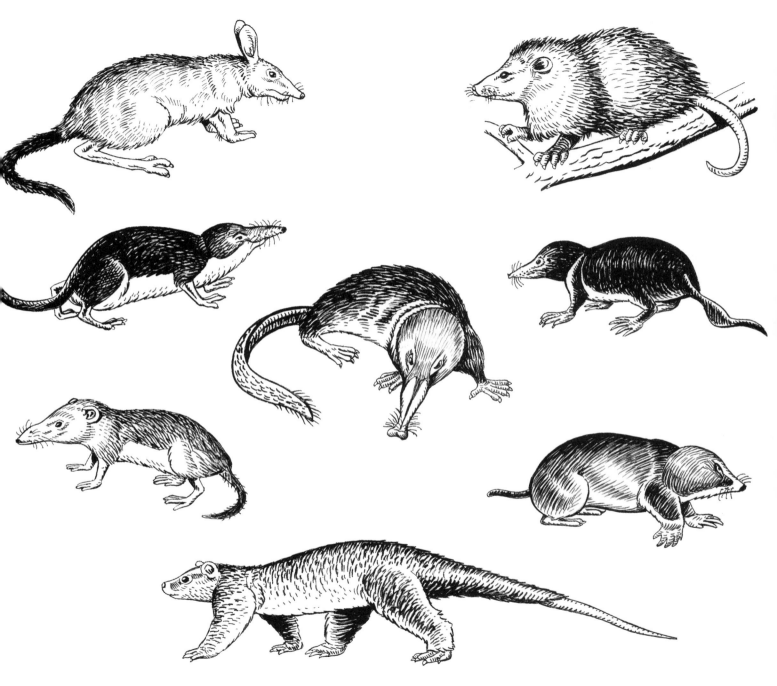

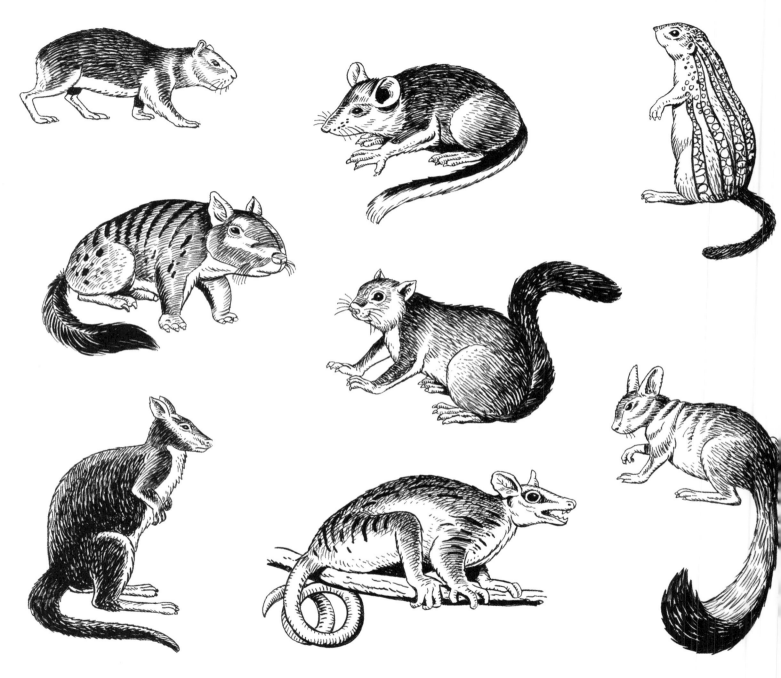

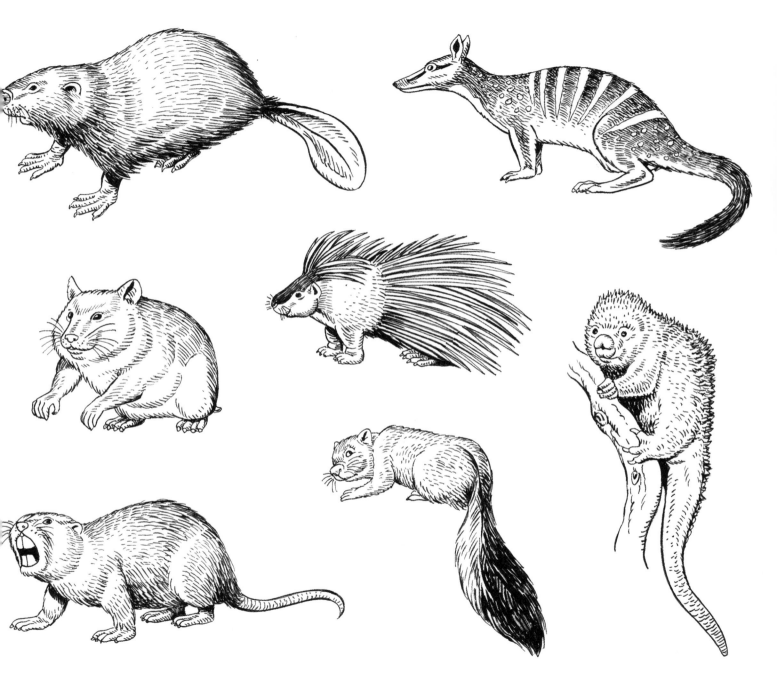

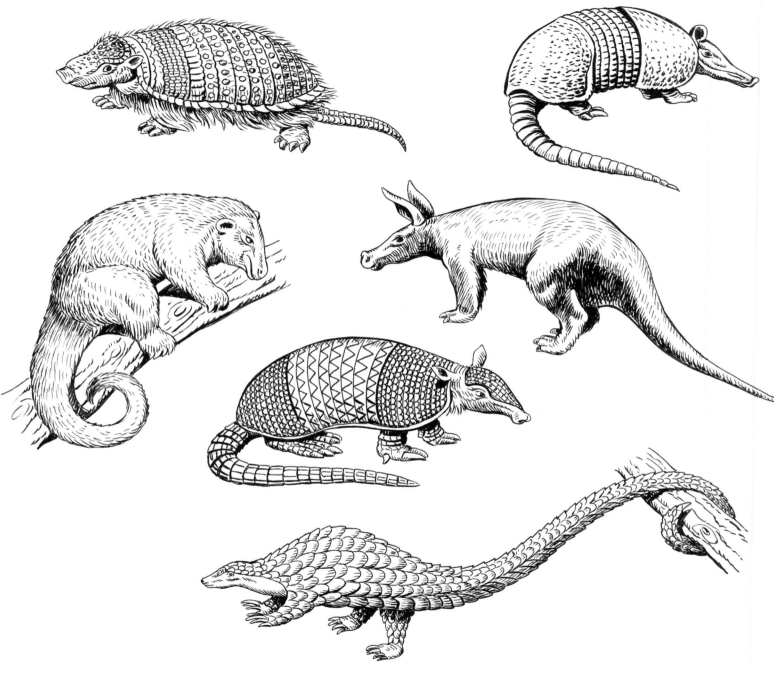

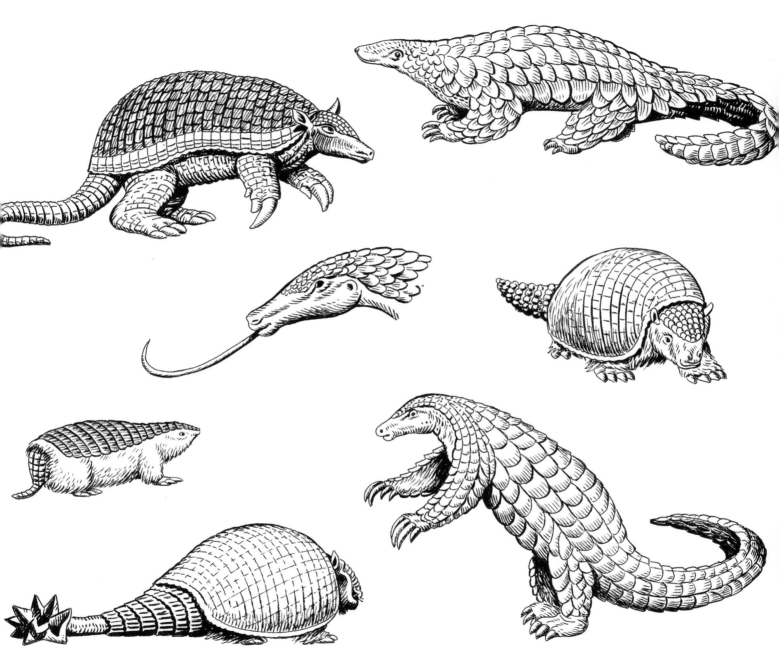

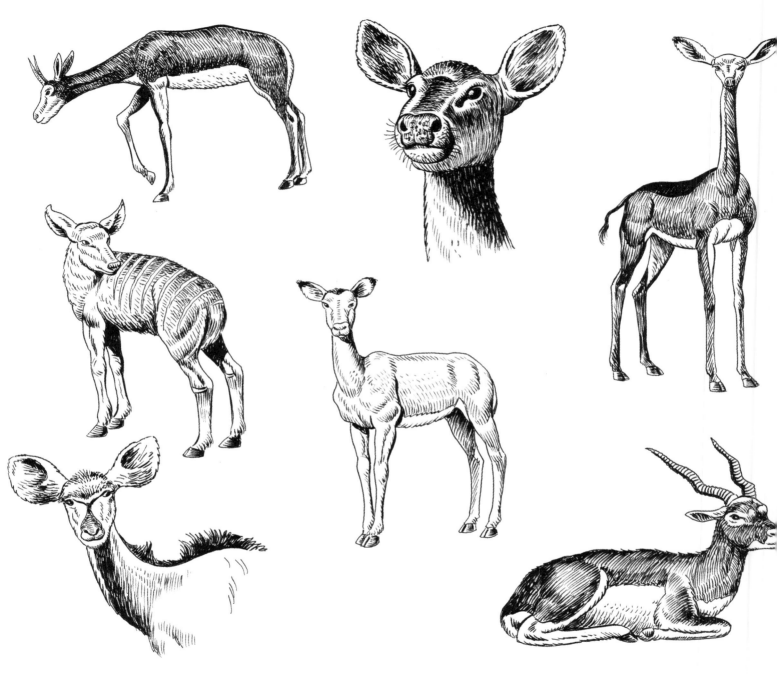

 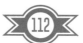

 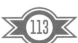

 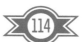

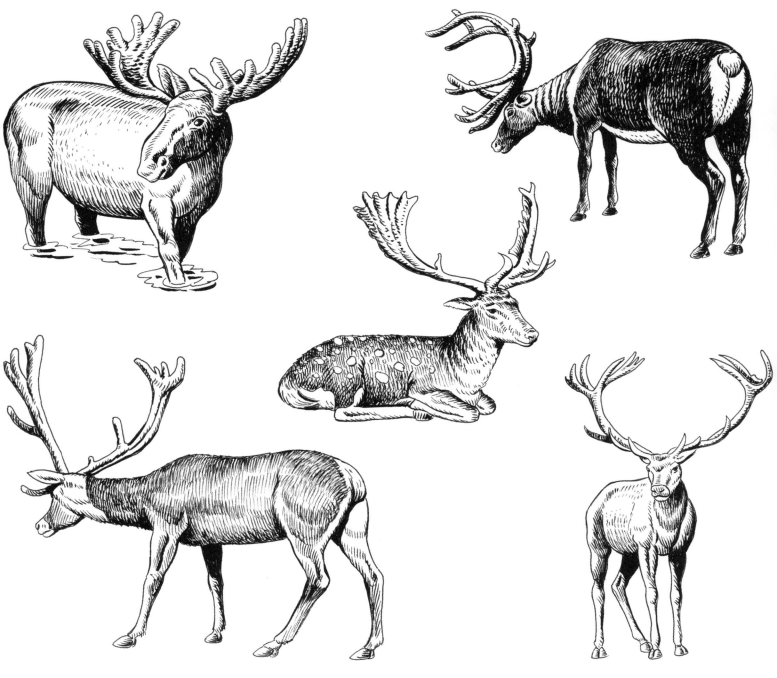

 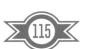

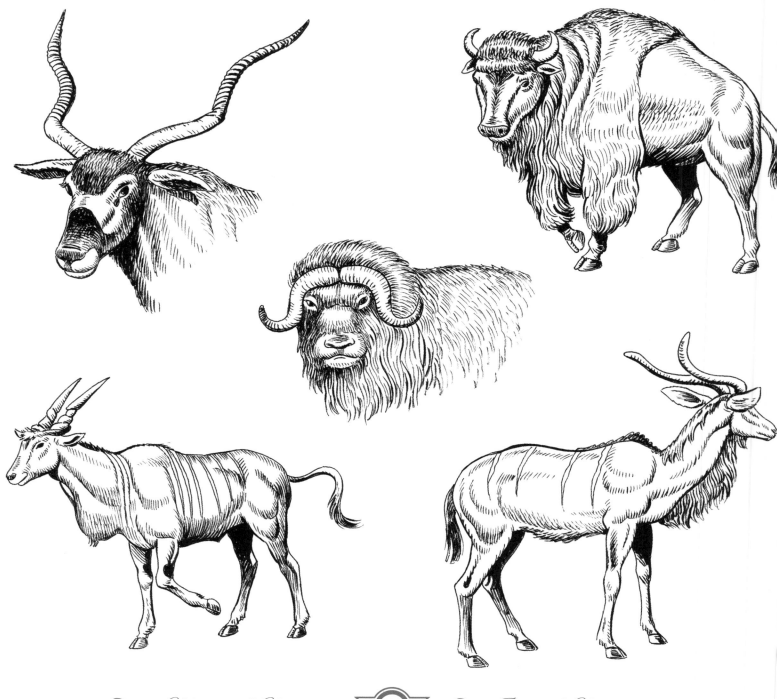

 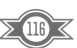

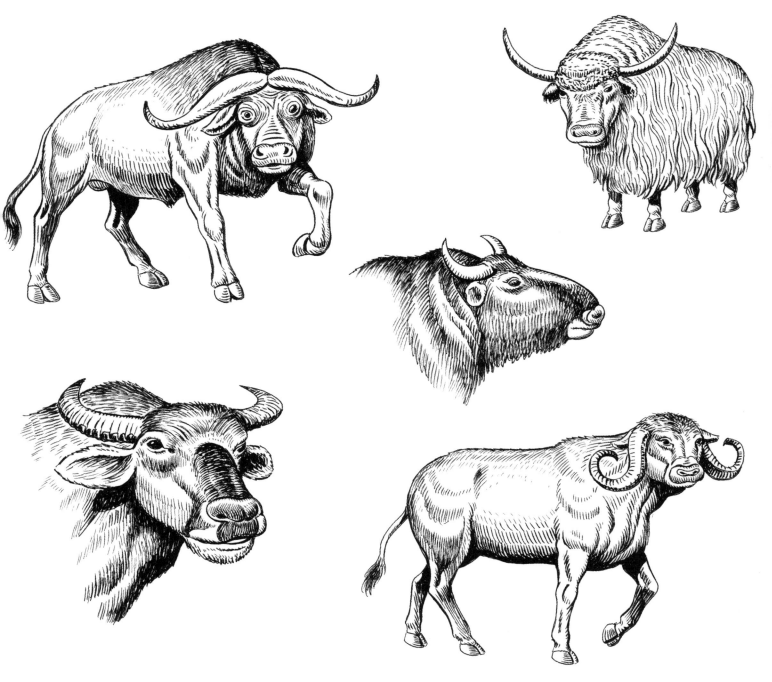

 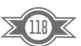

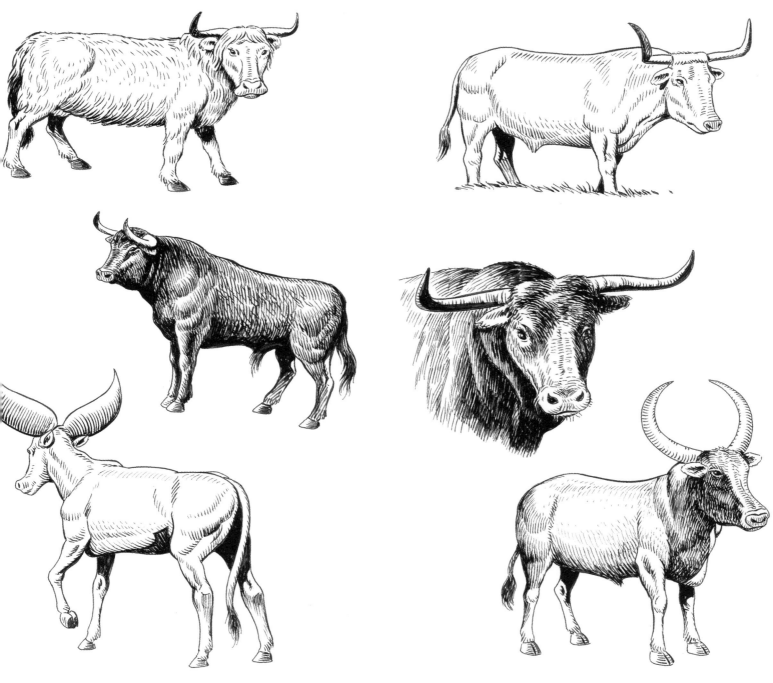

 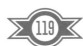

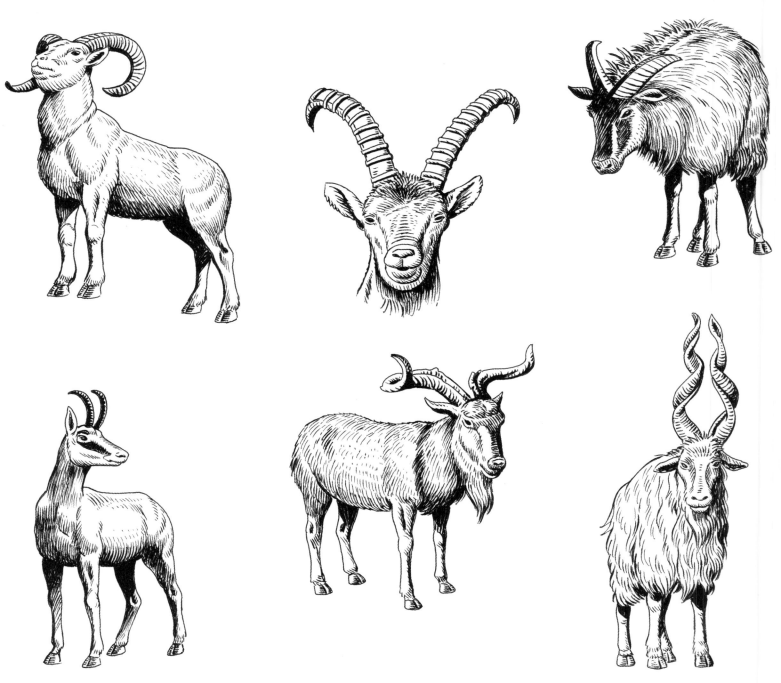

 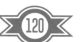

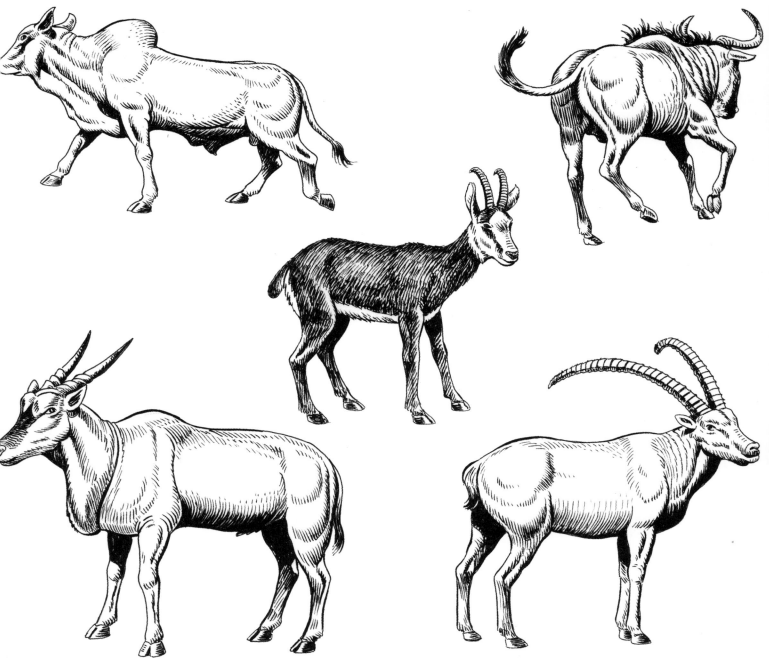

 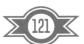

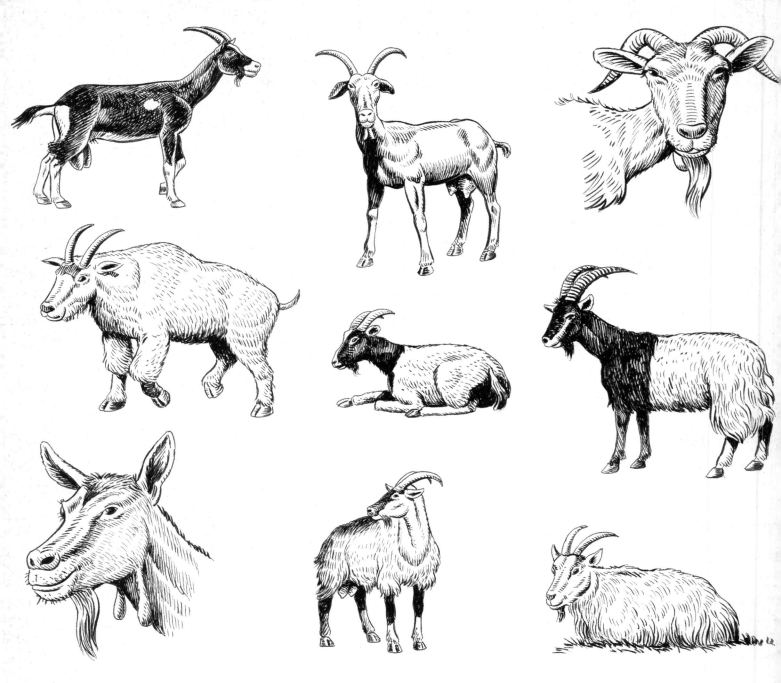

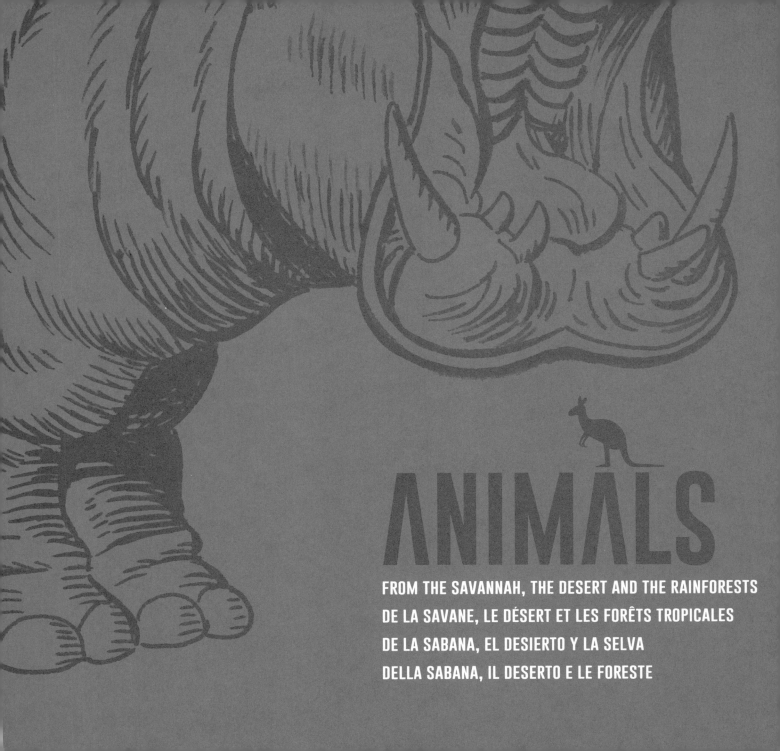

ANIMALS

FROM THE SAVANNAH, THE DESERT AND THE RAINFORESTS

DE LA SAVANE, LE DÉSERT ET LES FORÊTS TROPICALES

DE LA SABANA, EL DESIERTO Y LA SELVA

DELLA SABANA, IL DESERTO E LE FORESTE

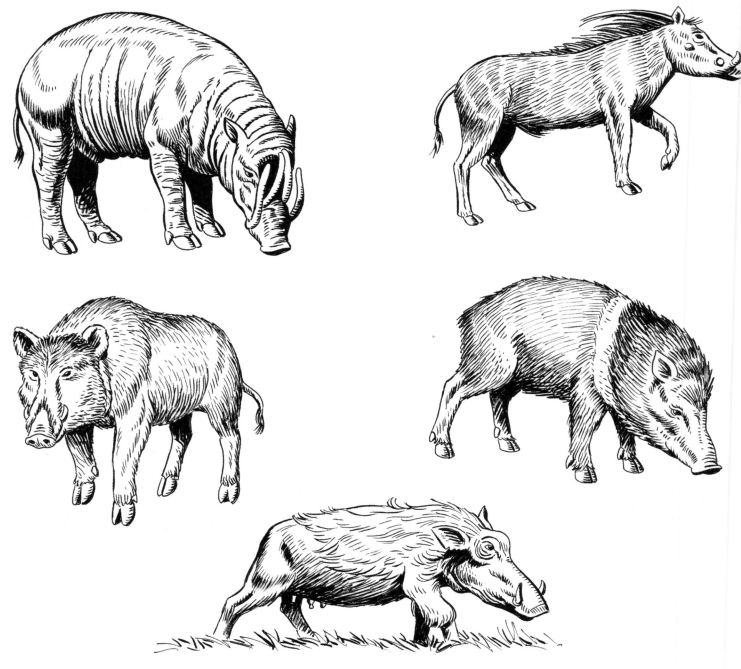

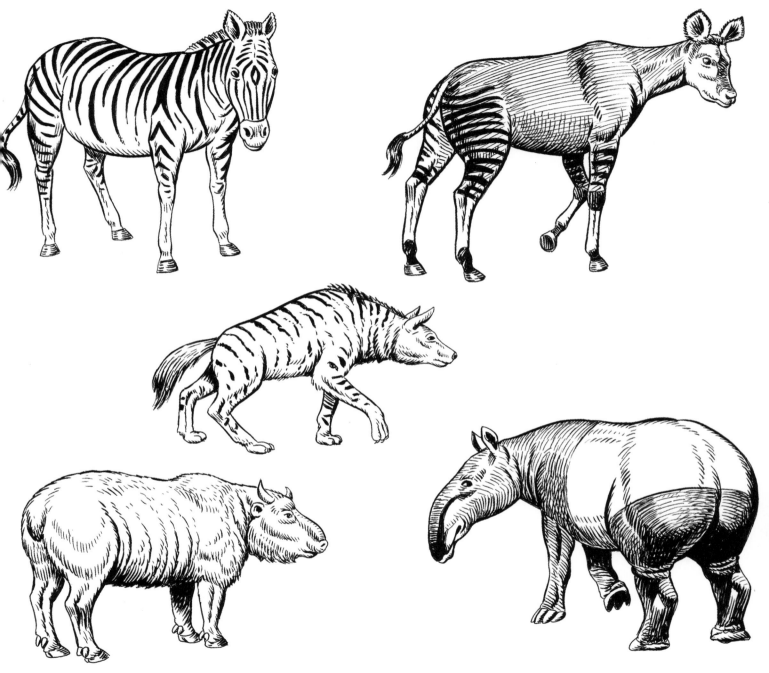

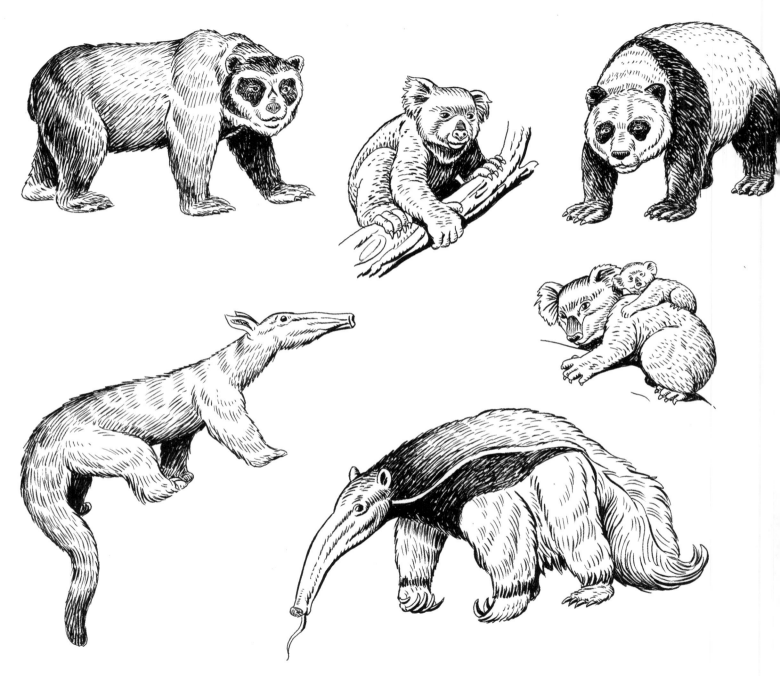

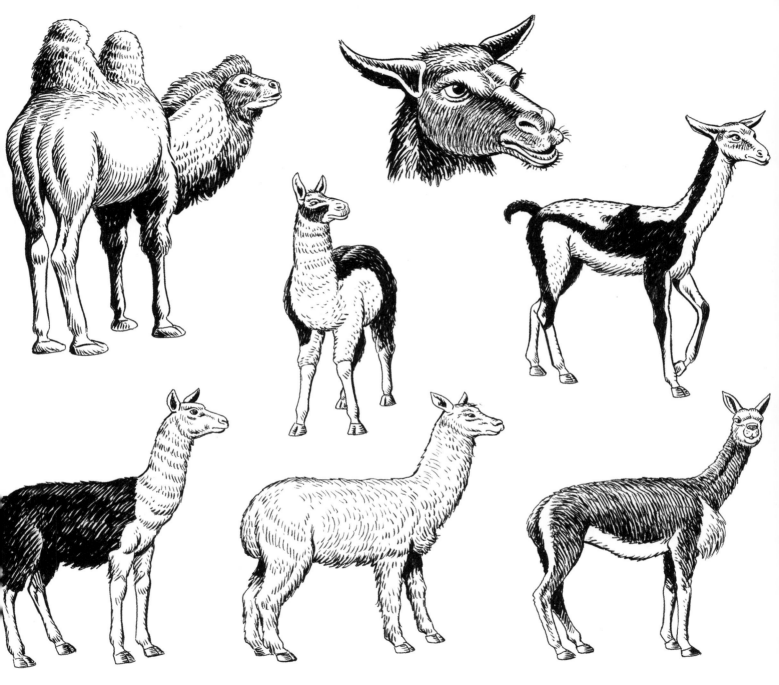

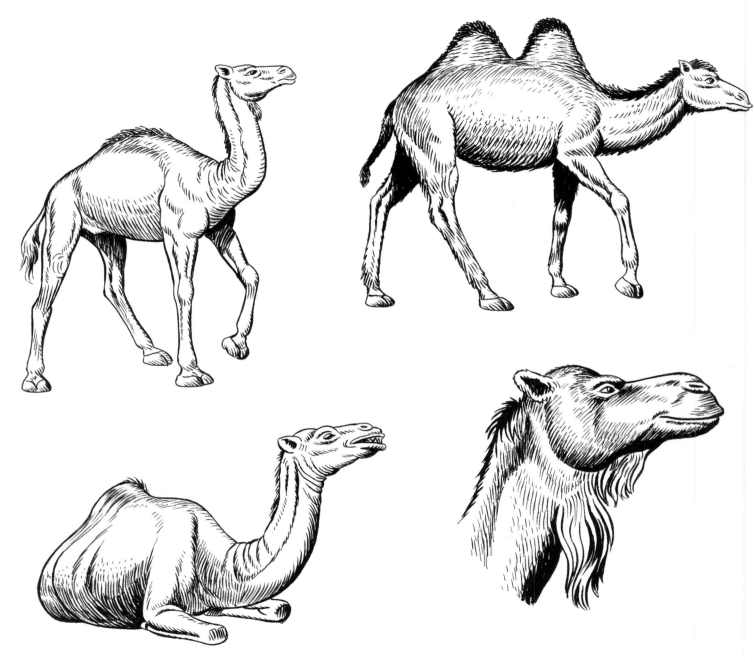

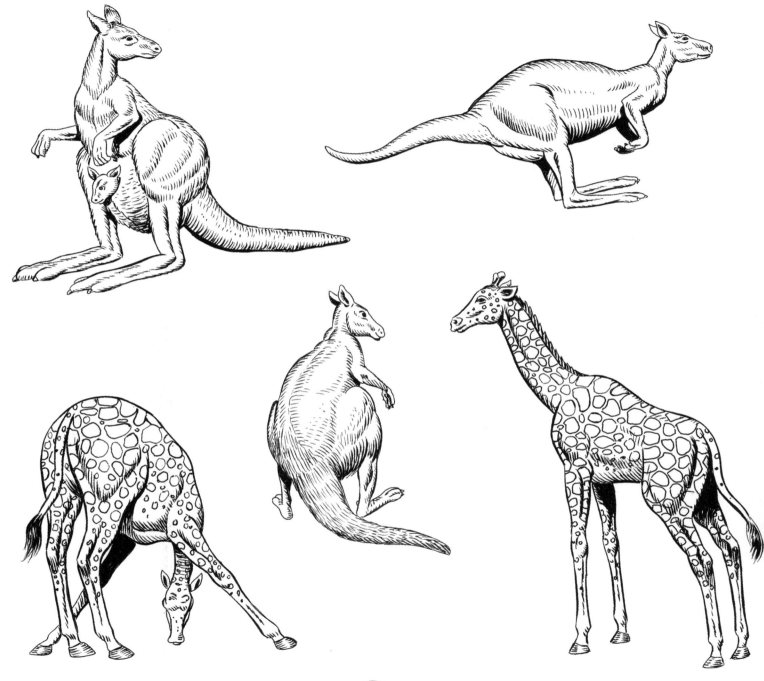

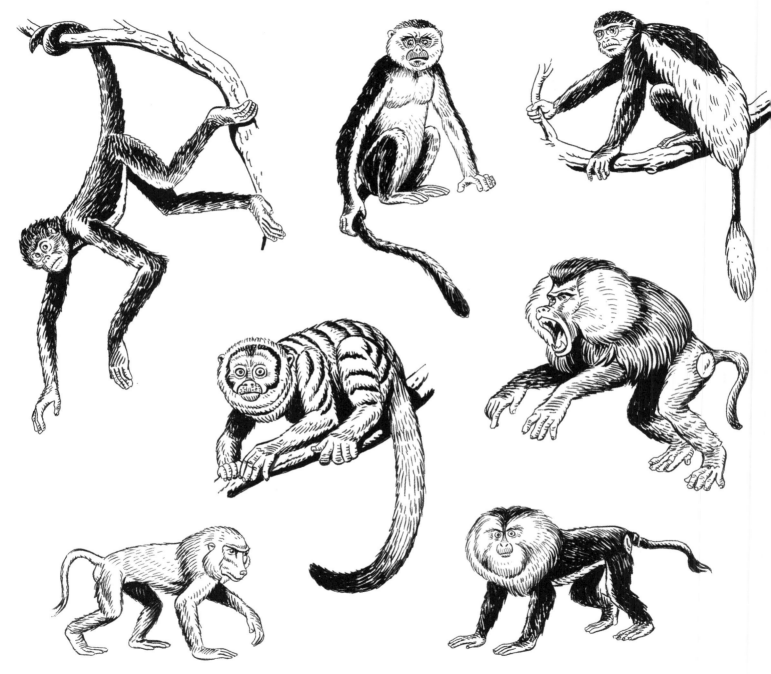

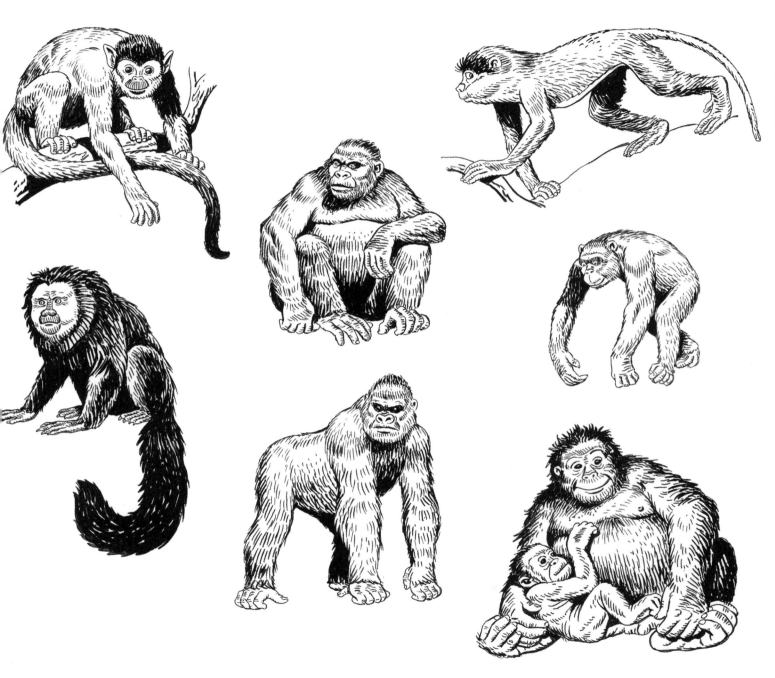

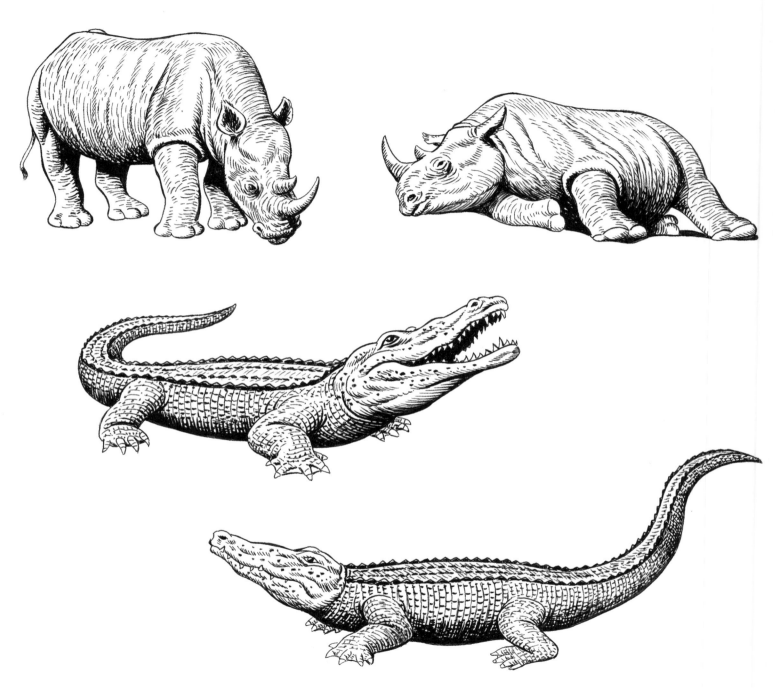

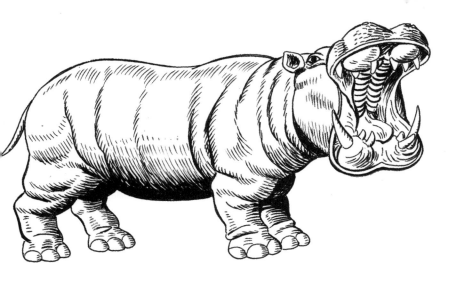
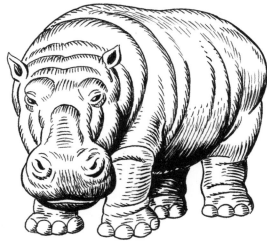
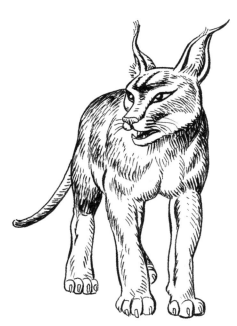
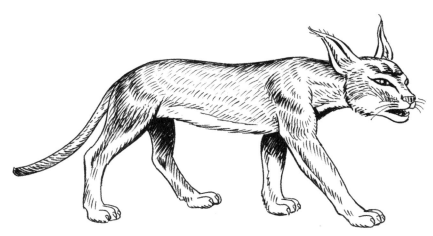

 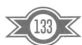

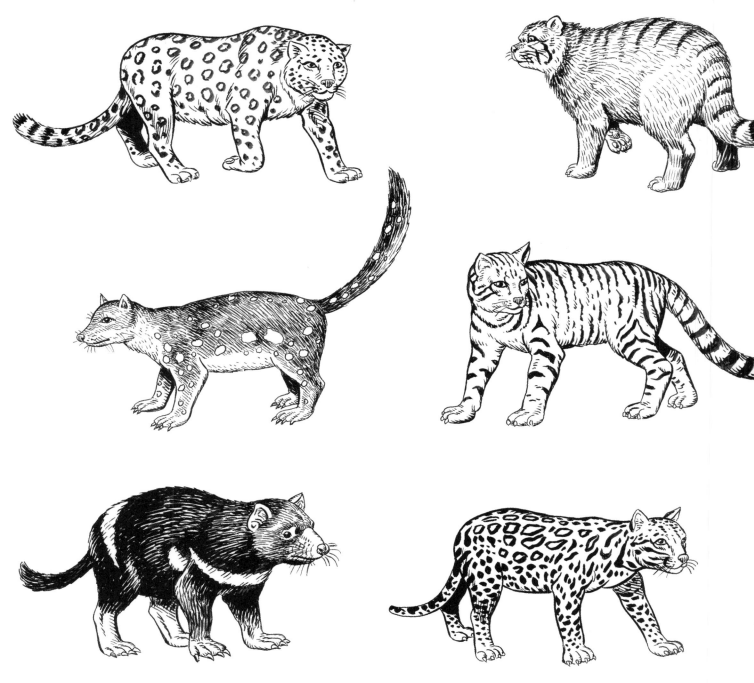

 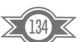

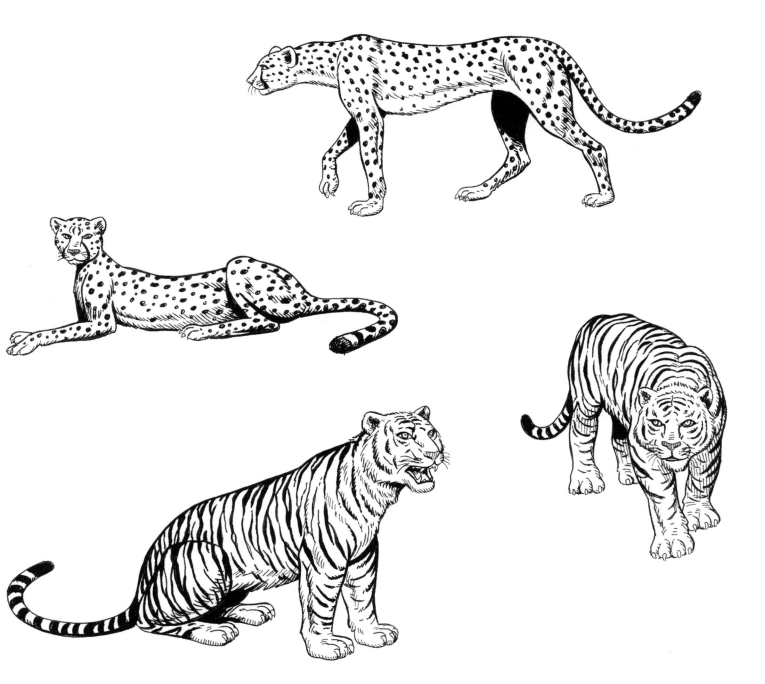

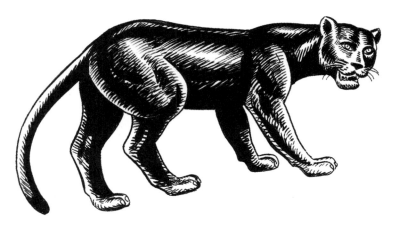
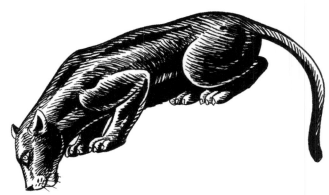
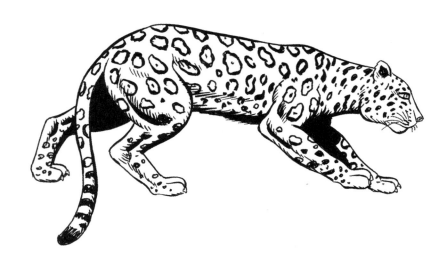
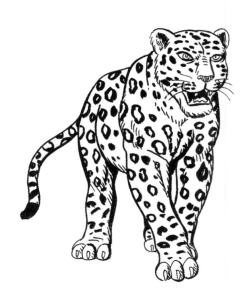

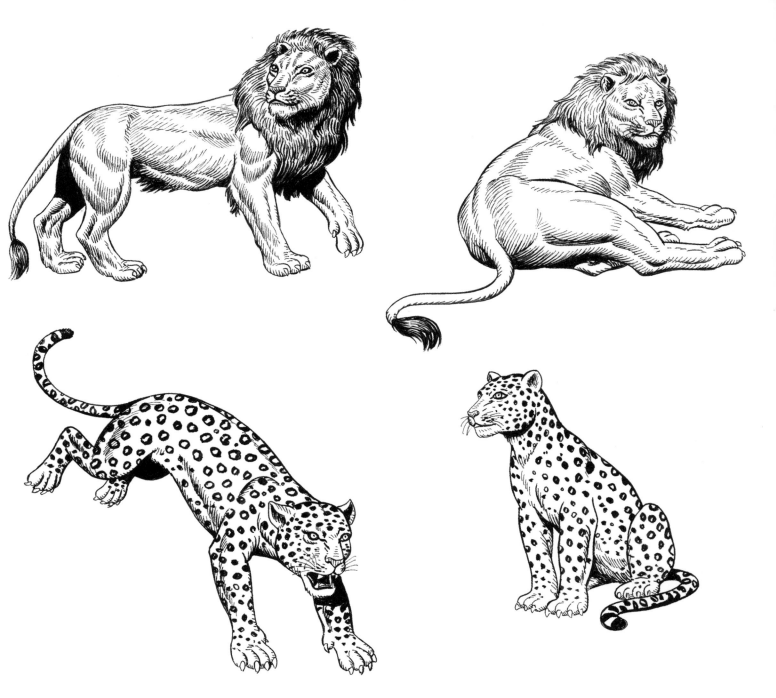

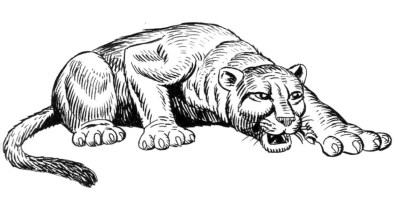

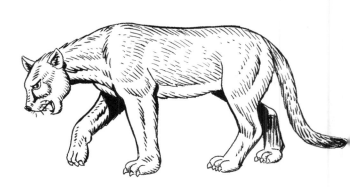

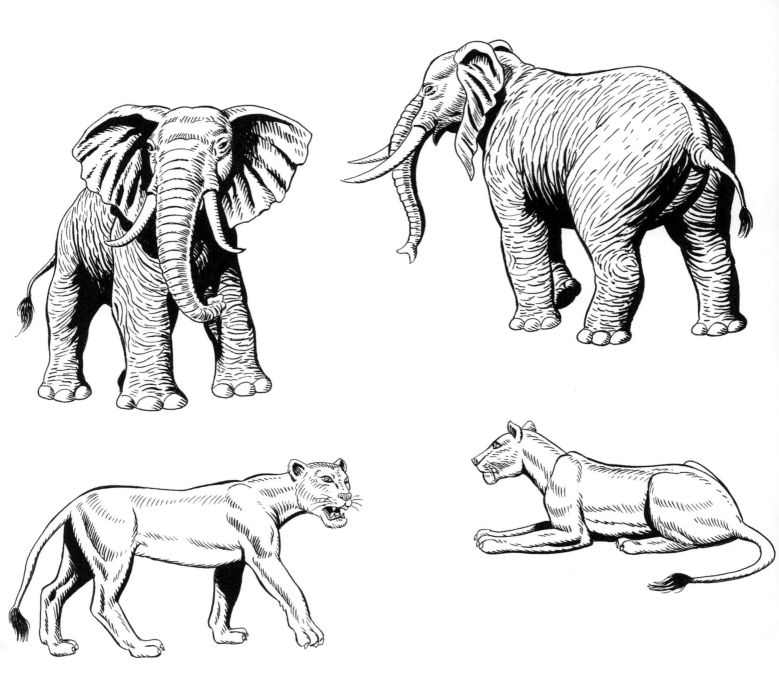

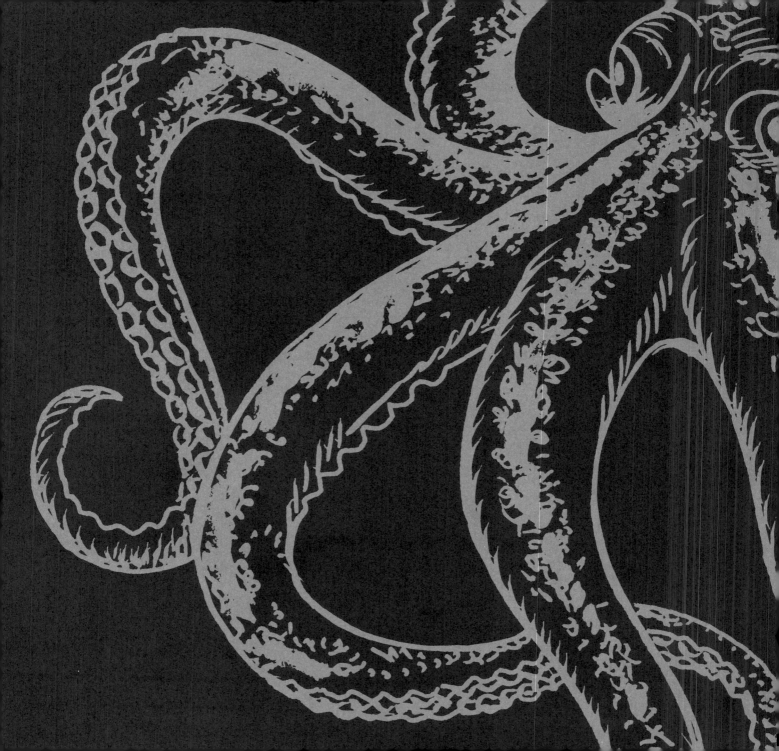